SKILL
SET

Knowledge Resource
& Educational Series

GRAPHIC DESIGN

by Michael MacGarry

DAVID KRUT
PUBLISHING

DAVID KRUT PUBLISHING
140 Jan Smuts Avenue
Parkwood 2193
South Africa
t: +27 (0)11 880 5648

DAVID KRUT PROJECTS
526 West 26th Street, # 816
New York, NY 10001
t: +1 212 255 3094

www.davidkrutpublishing.com

Written, designed and illustrated by Michael MacGarry
Text copyright © Michael MacGarry 2008
Design in the African Context © Garth Walker 2008

ISBN – 978 0 9814042 0 2

Author's Acknowledgements –
Sincere thanks to Bronwyn Law-Viljoen and all the contributors to this project: Peet Pienaar
and The President, Garth Walker and Orange Juice Design, Richard Hart and disturbance, Lou
Louw and Fever Identity Design, Joh Del, am i collective, Scott Robertson and Kim Longhurst
of The Curators, Carina Comrie, Olivier Schildt and Rex, CODE, Jason Bronkhorst and Infiltrate
Media, Kudzanai Chiurai and DOKTER AND MISSES, Givan Lötz, Gregor Graf.
Special thanks go to my family and Lucy Rayner.

Printed by Ultra Litho, Johannesburg

SKILL
SET

Knowledge Resource
& Educational Series

DAVID KRUT
PUBLISHING

Fire, is simply the sun unwinding itself from the wood.

– Buckminster Fuller

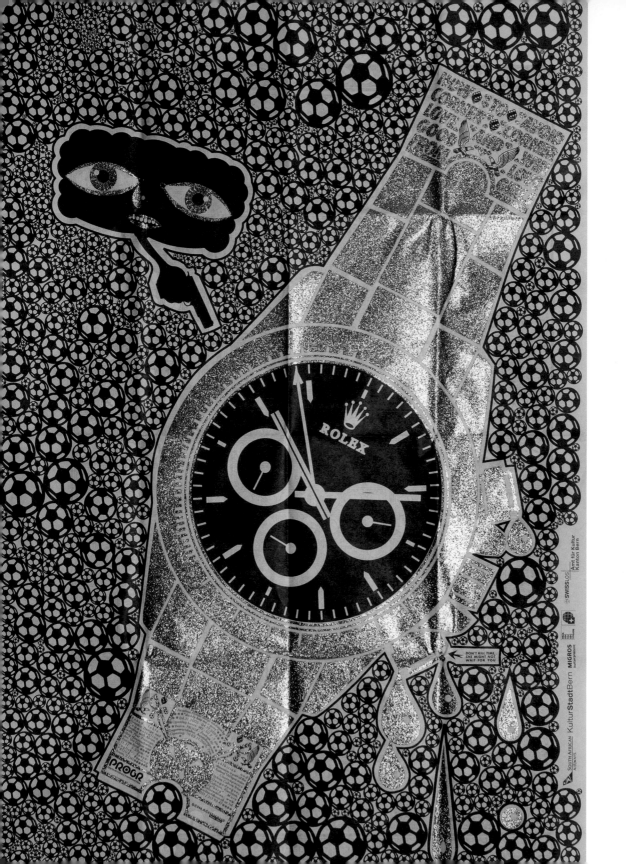

THIS IS THE CONTENTS PAGE

Opposite:
A1 invitation and poster designed by Peet Pienaar for a design exhibition for *Afro Magazine*

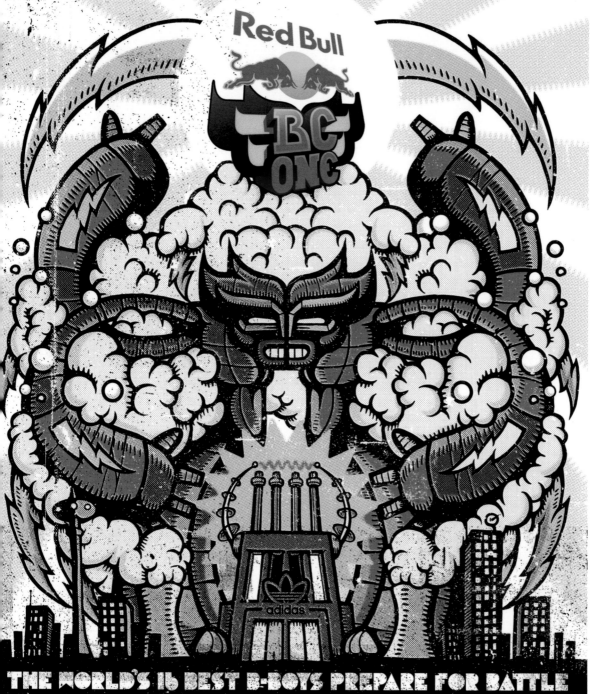

Red Bull BC ONE

adidas

THE WORLD'S 16 BEST B-BOYS PREPARE FOR BATTLE

22ND SEPTEMBER 2007
ORLANDO POWERSTATION, SOWETO

TICKETS AT WWW.COMPUTICKET.COM OR CALL 083 915 8000 FOR BOOKINGS AND ENQUIRIES.

WWW.REDBULLBCONE.COM

This is the Preface

by Bronwyn Law-Viljoen
Managing Editor, David Krut Publishing

Skill Set is a new series of books on South African design. It is the first fruit of many discussions with teachers, students and those who work in the design industries about the need for material that features local content and showcases the work of local industry practitioners. We have long wanted to create a series of books that serve as inspiration for aspiring designers and as handy reference works for emerging and established practitioners, but that also, and perhaps most importantly, celebrate the work of the many talented creatives who have set up studios or solo operations in various parts of the country.

Skill Set 1 – Graphic Design, the first in the Skill Set series, is more than a design manual. It is an introduction to the work of a number of graphic designers who have achieved local and international acclaim for their iconoclastic approach to design, their innovative interpretations of various forms of print media and their contributions to a local design vernacular distinct from the design languages of Europe and the United States. It demonstrates, beyond any doubt, that local is certainly lekker. This book does not, however, claim to be definitive. It is, we hope, an opener for many further publications in this arena that feature a greater variety of designers with a wide range of design identities. We hope that it inspires young designers to emerge from the relative anonymity of large agencies and make names for themselves in small studios or as independent designers. The individuals whose work appears in this book have achieved success in this way and we trust that future books on design will feature longer lists of talented designers.

David Krut Publishing hopes that Skill Set will help to cultivate a whole new generation of designers and that schools and tertiary institutions will not only encourage learners to choose careers in the design industries, but also help to provide opportunities for those who demonstrate passion, ability and dedication to this work. Design, after all, is about interpreting, shaping and transforming the world we live in.

Opposite:
Poster design from a complete campaign design featuring flyers, posters, trophy design and animation by
am i collective for the Red Bull BC One Event

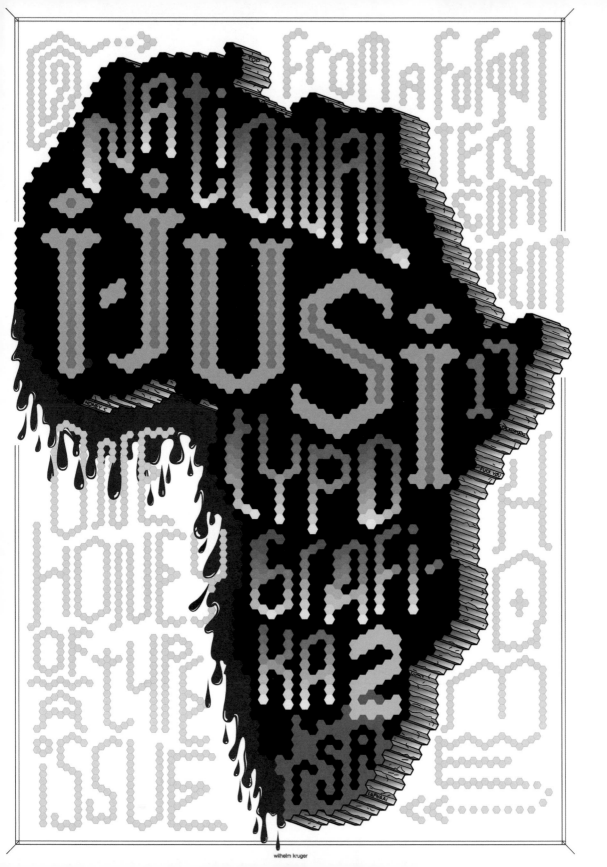

wilhelm kruger

This is the Foreword
by Michael MacGarry

Design is a subjective, personal, creative and idiosyncratic process that is approached, researched and realised by each individual designer in totally different ways.

There are no rules.

The way each designer engages with, articulates and executes either a given brief, problem solution or a creative intent is what differentiates one designer from another. In this book you will find a number of designers and artists who see what they do and how they do it in intensely personal ways. The languages they use to describe what they do differ on a number of fundamental levels, from one person to another and from one collective or company to another. You will also read and see that there are similarities to how we collectively understand and articulate the processes, problems and successes of this strange creature called graphic design and, by extension, creativity in general.

This book is meant to encourage and support someone who intends to pursue graphic design and their personal creativity as life-long endeavours. If you are reading this book you are probably already that person. Design is an elastic, slippery mist that drives those engaged in its murky joys to change the world as they see it. To re-articulate the materiality of their context with the intent firstly of communicating ideas and languages, and secondly of offering systems, patterns and models for viewing the world – allowing others to understand what they are looking at and where they are. They then have the tools to determine firstly what it is that they want to do with the world, and secondly how to do it. It sounds vague because intrinsically it is; the designers and artists included in this book offer infinitely more than just practical advice. If you only want to know how 'to do' graphic design this is not the book for you. Should you wish to pursue a career in this field with the intent of creating remarkable work for the benefit of yourself, your clients and the world at large, then this book will encourage and motivate this intent in you by offering an honest view of what it is you are in for.

What you do with this is entirely up to you.

Opposite:
Cover design by Wilhelm Kruger for *i-jusi* #17 (national typografika 2) published by Orange Juice Design

1

Opposite:
Illustration by Jason Bronkhorst, Infiltrate Media

1 This is the Introduction

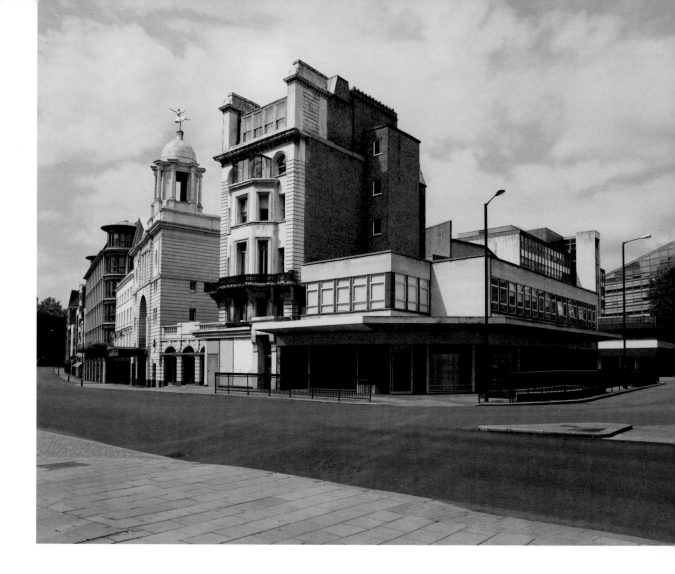

Imagine a world without signage, information, branding, logos, notices, billboards, directions, posters, instructions, fire escape signs, warnings, traffic lights, shop signs, addresses, graffiti or street names.

This is to imagine a world without graphic design.

These two images above are by Austrian artist Gregor Graf. They were taken in London. The artist digitally removed all signage, text, design and information from the buildings, street markings and road signage. These images show a barren, desolate wasteland devoid of any graphic, diagrammatic, linguistic or informational design. London looks quite strange doesn't it, like a ghost town? Perhaps it even looks quite pleasant? This is because the vast majority of graphic design in the world is badly made – produced in a hurry, or by someone inexperienced or who simply could not care less and just wants to get the job done and get paid. Or maybe the client was forceful and went for the ugly option, or the client asked the printers to pull something together quickly. Or maybe the adverting concept in that billboard selling sandwich spread was seen as more important than the graphic design. Whatever the case, it is your job as a graphic designer to take responsibility for the world you live in. Do not fill it with more of the visual pollution Gregor has painstakingly removed in his photographs.

Do not be lazy. Make work you can be proud of.

As a graphic designer – like an architect, city planner or engineer – you are responsibile for the material reality of the world we live in. You have a huge impact on what our world looks like: how well it works, how easily it is understood and how effectively ideas, information, products and knowledge

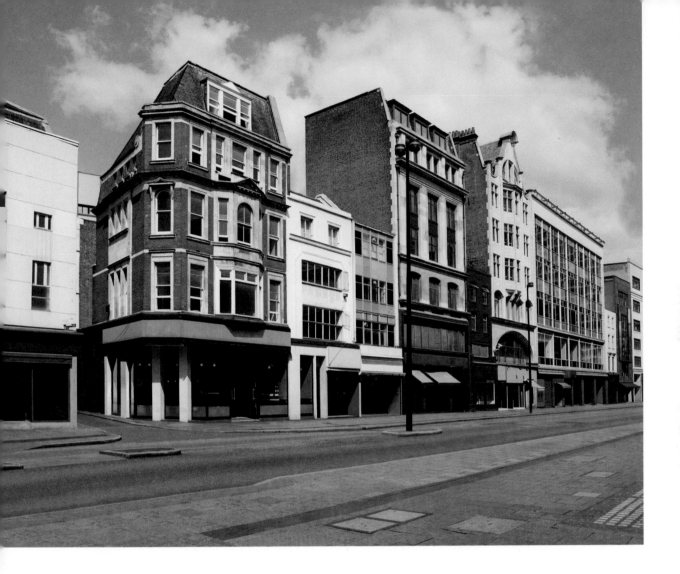

are exchanged, sold, bought, swapped, delivered, enjoyed and remembered. So own this responsibility and make work of value that has a positive impact on the world in an economic, social, visual and evironmental sense.

One of the ways to do this is to be constantly aware of your context; the immediate world around you – what does your toothpaste tube look like? Does its packaging design using green and red colours make you want to brush your teeth? Are green and red colours appropriate to dental products? What do green and red as colour personalities make you think of? Green might make you think of outdoors, nature, calm and cool or even something diseased and rotten. Whilst red probably conjures images of heat, brightness, anger, raw meat or pain. What does this have to do with dental care? If you were to design a better toothpaste tube what colours would you use? What would you call it? What font would

the name be in? Apply this thinking to everything you see around you, for there are two key elements that can be said to manifest that elusive thing called *inspiration* better than anything else:

OBSERVATION + HARD WORK

Being conscious of and actively engaging with your surroundings makes you look, observe, record, question and understand the place you live and work in. Working hard (and by this I mean in a dedicated manner, not obsessively and not all the time) means your personal language of signs, colours, shapes, words, tools and associations constantly expands and develops, allowing you to communicate better. As that one-time golfer Gary Player said;

"The more I practice, the luckier I get".

2051 B.C.

2008 A.D.

To design is to create images which communicate specific ideas in purely visual terms and utter statements whose form graphically embodies or enhances the essential nature of the notions to be communicated.

– John Commander

 ManiPedi
NAIL BAR · FOOT SPA

 FORCE ON FORCE

 PETROSHKA

THE PAVEMENT SPECIAL

 Qualica

 Central

 the ROCK

 young guns

 SILVER BIRD SAFARIS

D4 PROPERTIES

kuka-me

 IRC
INTERNATIONAL
RESOURCE CONNECT

 SAPPL
SOUTH AFRICAN PROFESSIONAL PAINTBALL LEAGUE

 Or Until the World Improves

 XSITE MEDIA

 jh0l

SSC
Skillsearch

ZULU KINGDOM
THE GATHERING OF LEGENDS

**ALL THEORY.
NO PRACTICE.**

GroundBase PROFESSIONAL LAND
DEVELOPMENT SERVICES

 storm

 Modern Amusement

OriginalBoats

 SHEPSTONE
GARDENS

CORNUTI

Cornuti

On these two pages are all the finished logos I have ever designed. This forms part of my visual contribution to this planet, a subject I described earlier. Some of these logos I am proud of and for others my associations are quite complicated. Sometimes the client cannot see what you are showing them or what you are telling them, or they do not want what you are giving them. Behind each one of these logos are three, four or more versions that did not make it, were not chosen and were not used. In spite of this there must be something – usually the process of making itself – that keeps you going, keeps you inventing. Because design is subjective (based on personal opinion) it can be a frustrating process, and often you will find yourself losing the battle to win the war. For example, you might concede to a client's request to alter a logo colour, but in so doing you are able to retain your original icon silhouette. Be passionate about your work, but keep your ego in check – the fact that there are no rules can work for you as much as it can work against you. In your career you will be asked to produce design work for a myriad different companies, individuals and institutions, but over time you will find yourself engaged in similar patterns of thinking and creating again and again – staying inspired, motivated and fresh is challenging. In my experience hard work and research help hugely in producing new designs for similar clients or industries. Do not copy, but critically observe and free associate. Design publications and the internet are tools – cultivate a design library and learn to use online resources to your advantage.

1 Every human being on this planet has an opinion. enemy of creativity, but never ignore the business edit it yourself, and publish it yourself. Mail it know. 5 Keep it simple. 6 Work hard. 7 Always take treat your suppliers with the utmost respect. 9 is always slave to practice. 10 Design an old thing way. Then, design a new thing in a new way. 11 styles – whilst developing a clear understanding 12 It does not always seem like it, but all new you know can be learnt on the job. 14 Always try and colleagues. 15 A sense of humour helps in you receive money from is a client. 17 Try hard to to get your client to understand you. 19 Design is best communicator you know. 20 Learn how to change it". 22 Always insist on respect from your promotion. 24 There are no small design jobs, only you have on the environmental sustainability of social impact of your work. 27 Critically observe, You are never ever too old to learn new things. 29 are essentially self-taught. Learn your language. Practice as a visual artist. 32 Constantly research, with others is essential. 34 Computers and design not an end in themselves.

2 Always keep your ego in check. 3 Structure is the aspect of being a designer. 4 Design it yourself, to everyone you know and others you want to informed risks. 8 Demand excellence, but always Practice does not always follow theory, but theory in a new way, and design a new thing in an old Be open to a wide range of influences, tastes and of your own preference. Know the difference. work is unique. 13 Who you know is vital. What to maintain contact with past employers, clients many ways. Honesty helps even more. 16 Anyone really understand your client. 18 Try even harder about communicating, so learn to become the say: "No". 21 Learn when to say: "OK, fine I'll client. 23 Everything you design is a form of self- small designers. 25 Be conscious of the impact the planet. 26 Where relevant, be aware of the everything. Learning how to do this takes time. 28 All designers, whether they have studied or not, 30 Always make time for your personal work. 31 become a sponge. 33 Collaborating and working software are tools – they are simply a means and

2

Opposite:
Photograph by Garth Walker

2 Design in the African Context

by Garth Walker

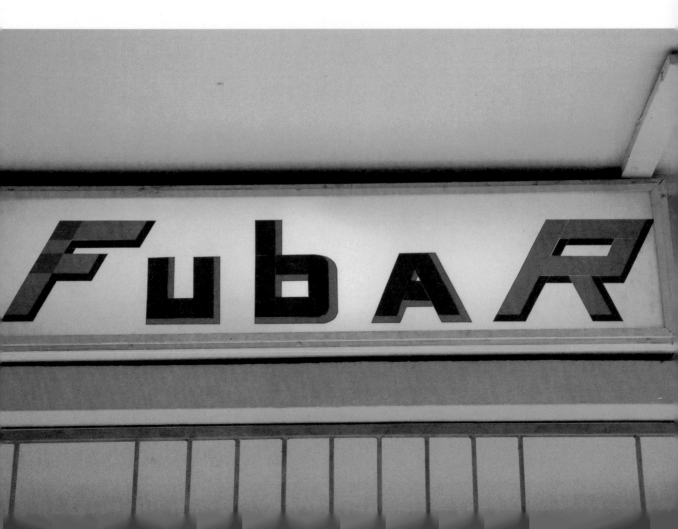

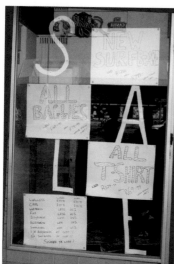

The first democratic elections in South Africa in April 1994 not only marked the crossover into a new South Africa, they heralded a new way of seeing. From that day on we started to look at society and our nation differently. We had the freedom to redefine ourselves, to rewrite history from the past, to feel renewed in the present and energised for the future.

Because from that day we all had the power.

And with that power has come a new sense of responsibility, at least for those of us who have become increasingly aware of the intimate connection between the individual and society.

For every personal action there is a communal reaction. And vice versa.

These actions are described in a powerful new visual language that everybody can understand. It mixes icons from the past and borrows from different cultures, blending them all into a new brother- and sisterhood. It is a visual language that starts on the streets and ends up in glossy magazines on coffee tables.

Our visual language is our most powerful traditional weapon. It is our tool of change.

For some, the very process of transition in this country is a crisis. For others, it is an adventure. The South African creative spirit, however, affects the way we see change. It brings together various forms of power (whether violent, political, racial, healing, spiritual, individual, national, you name it) and lays them on the table, or on the page in front of us.

I like to think of this as Design Power: the power of the creative juices now that they have been allowed to flow freely in a new South Africa.

If harnessed, Design Power will have a stronger impact on our culture than ever before. It is the inescapable power of a visual language rooted in the African experience.

Viva the power of design.

Opposite: **Store signage in the Johannesburg CBD**
Below: **Public park signage, Norwood, Johannesburg**

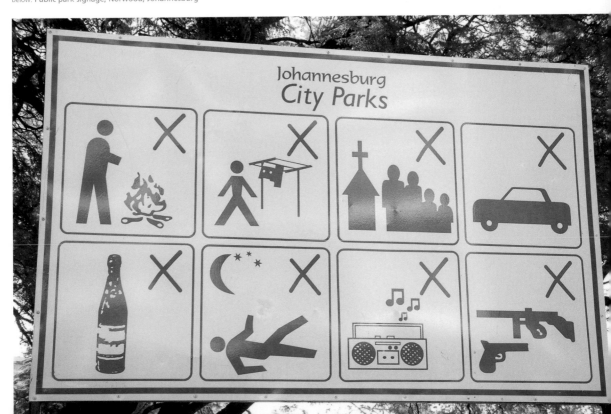

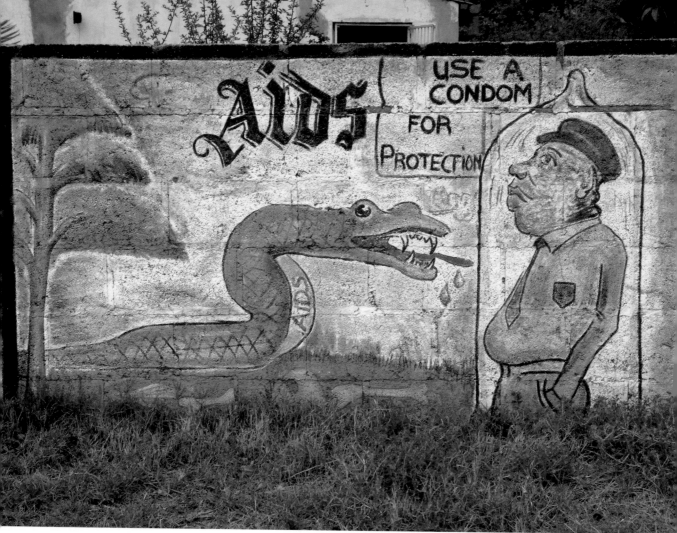

Above: HIV/AIDS wall mural, Carolina, Mpumalanga

Below from left: Pre-school signage, Qumbu, Eastern Cape; retirement home signage, Morningside, Durban

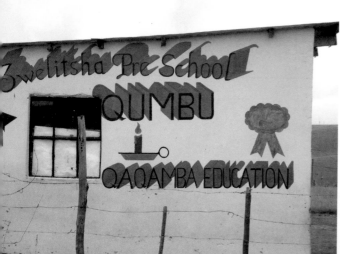

Much has changed in South Africa since the fall of Apartheid. More accurately, very little has remained the same. The unbanning of the ANC and the release of Nelson Mandela led to South Africa's first free and democratic elections and the Government of National Unity in 1994. Apartheid laws were abolished, allowing all citizens a freedom previously unimaginable. In politics, business, sport and on the streets it was now possible to see everything from a new perspective. At the same time we began to see many people, fleeing war and persecution, migrate into South Africa from Zimbabwe, Zambia, the DRC, Angola, Nigeria and elsewhere on the continent, seeking freedom and their fortune in Johannesburg, the city of gold.

Apartheid cities, however, were totally unsuited to this sudden influx of people. Many immigrants lack higher education or are functionally illiterate and therefore totally unprepared for what they encounter in South Africa. They have few choices about where to work and live. In the first years following the 'opening up' of the country, many survived by squatting on the sidewalks and open lots of the inner city. Living in shacks made from tin, plastic and other materials, they began to serve passing trade as fellow city dwellers went about their daily business.

Most South African cities now have large, illegal immigrant populations. And in the face of increasing xenophobia, it is more important than ever that the 'Rainbow Nation' reflect all of Africa equally. But the legacy of the infamous Group Areas Act is still evident: the leafy suburbs are still predominantly white, townships remain black, Indian neighbourhoods remain Indian. There are, however, many areas that are in transition, mostly in the cities where low-rent, no-questions-asked apartments abound. The mix of cultures is most striking in urban taxi ranks and bus depots where informal markets trade on the ebb and flow of commuters.

Several African countries have endured some form of political turmoil for decades and as a result their formal economies have been eroded. In spite of this, Africans remain intensely entrepreneurial. Refugees from the Congo, for example, bring years of experience in street trade, with skills in hair styling, sign writing, shoe and radio repair and catering. Many amongst them have university degrees but are forced into trading for lack of official documentation. Their influence on South African culture is becoming more and more evident.

Overnight, shoe repairers, personal-grooming suppliers, hair salons and general traders have sprung up on

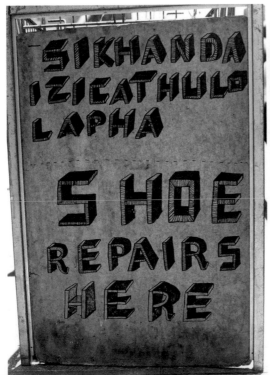

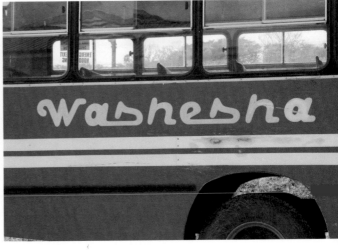

Above:
Bus livery, Empangeni, KwaZulu-Natal

Left:
Street trader signage, Umgeni Road, Durban

sidewalks and in taxi ranks. Intense competition and increasing specialisation have resulted in many traders having to advertise their wares or services and so hand-painted signs, murals and posters are now ubiquitous. Street graphic design is becoming increasingly sophisticated, even though the medium is transient. Much of the street advertising and signage is lost soon after it has been produced. It serves the trader as long as he or she trades. Signs and notices are destroyed through use to be replaced by other signs, pictures or displays.

Hairdressing is the most common kind of street vending in South African cities. Salons cluster on every corner of the taxi ranks, with stiff competition for prime positions at busy intersections. Because the stalls have to be erected in the morning, then disassembled and stored every evening, they are made from lightweight material: they are usually canvas gazebos with signs made of cloth. A very specific visual language has developed amongst the hair salons. The cloth signs are bright yellow and painted with several heads in profile or three-quarter view. The more affluent the vendor, the more elaborate and refined their sign. The Congolese painter Bruno Bihiza, who came to South African in the late nineties, was one of the earliest trendsetters in the art of the salon street sign. He set the standard with striking renditions of famous black actors, sports stars and politicians. He has gone on to a bright career in the arts in London and now his hair salon signs are collector's items. Other sign writers have emulated his style with varying degrees of success.

To differentiate their salons, vendors use inventive names and slogans to catch the eye of passing customers. Stall signs display the keen humour and irreverence of street style with names like 'The Ghana Hair Queen Unisex Salon' and 'Thank God Because I'm Black'. Many are adorned with the smiling images of famous people like rap star Tupac Shakur, Bafana Bafana defender Lucas Radebe, Patrice Lumumba and even Robert Mugabe.

African street sign writers have an infatuation with type and thus street graphics have reclaimed territory that the professionals have long forgotten. There is no Helvetica here, no Bank Gothic or kerning balanced on a knife-edge. Here is typography at its most passionate.

Since competitors are within arm's length, type has to attract the attention of potential customers. It plays with perspective and compels customers to come closer and take a look. It shouts its message, demands attention and dares one to smile.

Absent too is the minimalism that is so fashionable in contemporary graphic design. On the streets the spaces are pillaged and every gimmick is used to full effect. Drop shadows sweep in from the distance, typefaces shimmer and elaborate twiddles twist from the serifs. Often, poor planning forces the artist to cram in a word or add a small 's' where a plural was overlooked.

Humour and a happy-go-lucky attitude distinguish street type from its counterpart in corporate graphic design. Too often the trained eye and constant revisionism of contemporary design make us forget what is most obvious. Street signs exhort us not to over-think it, to have fun, to demand attention, to use a drop shadow now and again.

While corporates in South Africa still choose to imitate big business the world over with its austere fonts and perfect typesetting, there are signs that the ivory tower is beginning to pay attention to street vernacular. Fourteen years of freedom later, a TV ad here and a billboard there pay homage to street style. But one wonders if we'll ever really get it. In 1994, we had an opportunity to establish a new paradigm, to take the African Renaissance in both hands and run with it, to turn New York, London, Milan and Paris on their collective heads and declare our independence with an entirely new visual language.

South African street typography – and African vernacular type in general – has not yet had its day. Often dismissed as crude, verbose or unsophisticated by Western designers, its potential as a visual language may never be fully appreciated. Perhaps though, the African Renaissance will bear the fruit that its leaders promise and the twenty-first century will belong to fonts like 'Shoe Repairs', 'Afrodisiac' and 'iAlfabheti'. Our cities are a great mix of people and influences, and in 2010 the soccer World Cup will be our chance to showcase Africa to the world.

Above: Hair salon signage, Durban CBD

Below from left: Shop signage, Long Street, Cape Town; tavern signage, Johannesburg CBD

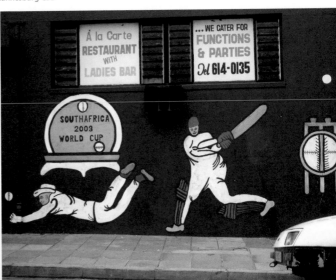

TIMBERS

CHIPBOARD
MASONITE
PLYWOOD
FORMICA
SHELVING
MELAMINE

· P.A.R PINE
· KNOTTY PI
 CEILING
· LAMINATE
 BOARD
· LOUVRE
 DOORS

OPEN,
COME
IN...

LINGEN
GARDENS

Right:
Bus livery, Overport, Durban

Below:
House, Umhlanga Ridge, Durban

Opposite clockwise from left:
Hardware store signage, Port Shepstone, KwaZulu-Natal; apartment building signage, Gardens, Cape Town; shop 'welcome' signage, Greenside, Johannesburg

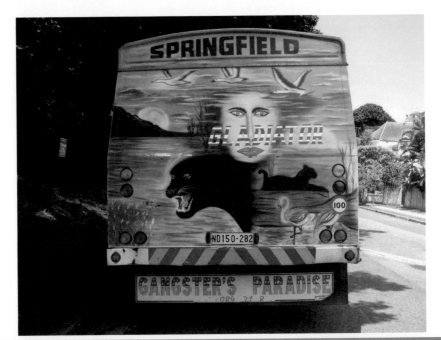

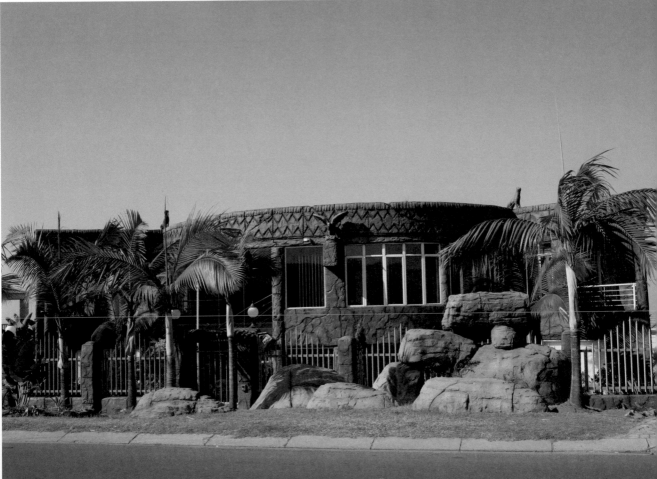

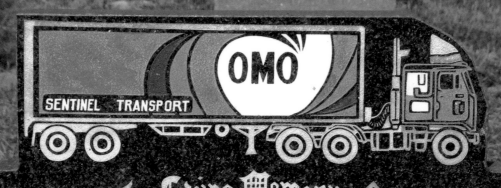

In Loving Memory of

MAHENDRA BRIAN NAIDOO

BORN 07 : 11 : 1966
DIED 13 : 02 : 1995
EVER REMEMBERED BY
YOUR FAMILY AND FRIENDS

GOD CHOOSES THE BEST THEY SAY
... CERTAINLY GOT THE BEST
... THAT FATAL DAY

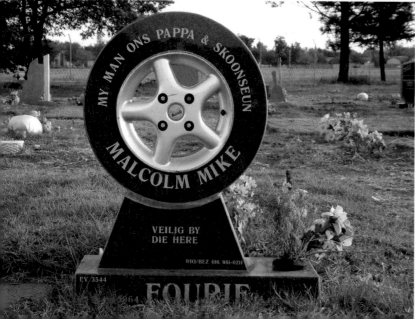

MY MAN ONS PAPPA & SKOONSEUN
MALCOLM MIKE

VEILIG BY
DIE HERE

RIO/BEZ 016 981-0211

EV 3544

FOURIE

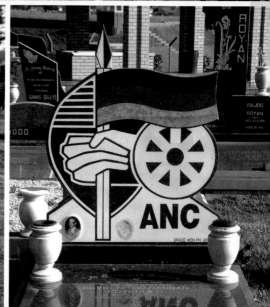

ANC

3 GRAVE IMPORTANCE

Death is inevitable for all of us but we spend little time thinking about it. It is an uncomfortable topic, still taboo in most cultures. We instinctively fear it, perhaps because we do not understand it. Nonetheless, it is the punctuation mark of our existence and when we die we all want to have made a difference, been someone famous, done something important to make the ending an exclamation. But more than this, the burial site is one more sign of the proliferation of a particularly home-grown visual language.

Burial allows the bereaved a chance to mourn, to mark the passing of a loved one and find closure. The places and signs of burial also offer an opportunity to signal the importance of an individual to friends, associates, contemporaries and the community.

In South Africa, cultural differences are nowhere more obvious than in our graveyards, even though Apartheid's war on multiculturalism is still apparent in segregated cemeteries. Burial places bear witness to a cultural history full of variety. There are graveyards that could be in middle England, the indigenous flora notwithstanding. Others are reminiscent of urban India, but most remarkable are the eccentric examples that can only be African.

AIDS is taking its terrible toll on our country. Many families do not have the means to bury their dead with dignity and so cemeteries that have the space now feature large informal sections: adjoining mounds of dirt without so much as a modest walkway between them. Some mounds have crude crosses, but most are marked only by a cube of concrete imprinted with a number. The funeral insurance plan is now ubiquitous in sub-Saharan Africa. The wealthy generally have theirs linked to provident funds and life insurance, while the less fortunate join funeral home clubs or burial societies. Club membership costs only a few Rands a month and gets the signatory a big discount on the entire proceeding, from casket to hearse, to the plot and the gravestone. Demand for the latter has spawned a trade in customised headstones. These remarkable objects offer wonderful insights into the aspirations of individuals and communities as well as demonstrating the innovative use of different media to convey a personal message in a public space.

In Chatsworth Cemetery, a traditionally Indian graveyard outside Durban, a magnificent polished granite stone features an eighteen-wheeler emblazoned with the Omo Washing Powder logo. The epitaph reads: "God chooses the best they say, and he certainly got the best on that fatal day." In a cemetery in Vanderbijl Park south of Johannesburg, a near-life-size granite replica of a Suzuki Superbike marks the final resting place of a young rider, taken too soon, his image framed in ornate gold leaf.

There are many such examples, dotted around the country, of final resting places decorated with personal possessions. Though these are the symbols by which individuals and their families choose to commemorate their lives, to strangers they invite more questions than exclamations about the tomb occupant's distinction. In their ostentation they prompt us to ask, which will offer the greater spectacle of our existence: life or death?

Opposite top:
Memorial headstone, Chatsworth Cemetery, Durban

Far left:
Headstone, Vanderbijl Park Cemetery, North West

Left:
Headstone, Chatsworth Cemetery, Durban

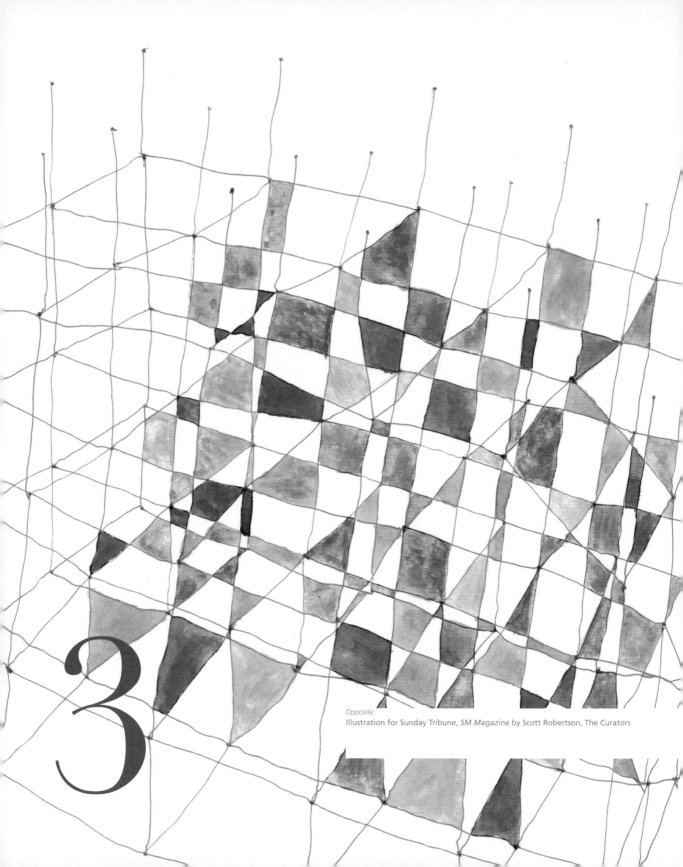

3

Opposite:
Illustration for Sunday Tribune, *SM Magazine* by Scott Robertson, The Curators

3 The Principles of Design

Design Is + Design Is Not; The Principles; Unity; Hierarchy; Proportion; Balance; Rhythm; Composition; The Grid

DESIGN IS {

- TO PLAN
- TO ASSEMBLE A WHOLE FROM DIFFERENT PARTS
- TO BRING ORDER
- TO COMMUNICATE
- BASED ON OPINION
- TO MAKE INFORMATION ACCESSIBLE
- HELPFUL, FUNCTIONAL, EFFICIENT, DELIBERATE, INTELLIGIBLE
- A PRODUCT OF HUMAN INGENUITY AND CREATIVITY
- A FORM OF EXPRESSION
- CLOSER TO STYLE THAN TO FASHION
- A SERVICE
- OPEN TO INTERPRETATION

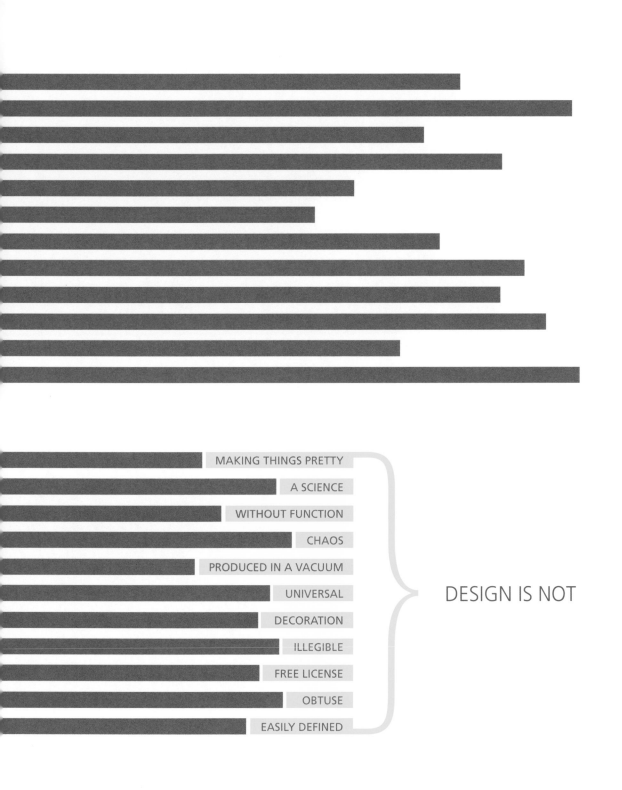

MAKING THINGS PRETTY

A SCIENCE

WITHOUT FUNCTION

CHAOS

PRODUCED IN A VACUUM

UNIVERSAL

DECORATION

ILLEGIBLE

FREE LICENSE

OBTUSE

EASILY DEFINED

DESIGN IS NOT

THE PRINCIPLES

The principles of design are a series of different ways to assemble, manipulate and present the various elements of design outlined in the next chapter. How a designer implements the principles of design determines the form, feel and success of a design job. Through experience these principles will become second nature – you will use and refine them everyday in your professional life to the point where you won't even be able to really know what their individual names are or where one principle starts and the other ends, this is because they, like the elements of design, are always used together in a constant relationship or dialogue that forms the very fabric of your design. In this sense it is important to see that the principles of design are codependent and totally interrelated to the elements of design.

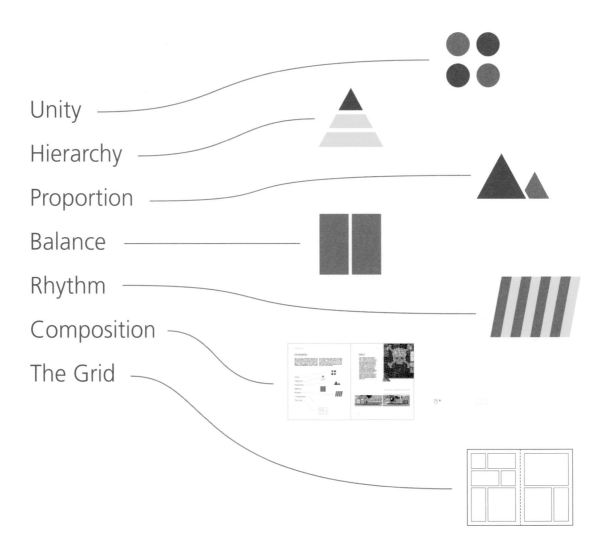

Unity

Hierarchy

Proportion

Balance

Rhythm

Composition

The Grid

UNITY

Unity refers to how the human brain organises and interprets visual information. In design terms, unity articulates both the visual connection of all the various elements in the design, as well as the composition as a whole. Unity can be used to visually link the design elements into a common whole, or it can be used to split up the composition to create variety and impact. By combining similar or related design elements – like complimentary colours, or colours of a similar tonal value or related shapes – a satisfying visual effect is produced. Use jarring shapes and tonally conflicting colours and your design will have a bold, dynamic and even a potentially aggressive feel. The nature of the type of unity employed in a design often relates to the subject matter being communicated. For example, an invitation for a piano recital would probably utilise subtle complimentary colours, horizontal lines and a softer feel overall, whereas an active, dynamic poster for a sports event might use oblique angles, bold contrasting colours and angular lines.

Above:
A page/poster in *Afro Magazine* 2, designed by Peet Pienaar

Below:
Illustrations for Sunday Tribune, *SM Magazine* (Left: Superjocks. Right: April Fool) by Scott Robertson, The Curators

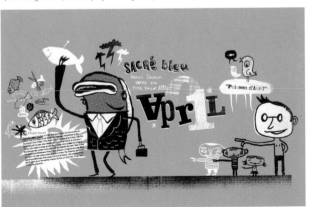

HIERARCHY

Hierarchy is basically a ranking system used to order or arrange information or elements in a design according to a system of importance or relevance. This system can be manifest through the emphasis of certain elements over others or through the use of dominance of one piece of information over another. Through the use of a determined hierarchy within a composition, the designer controls and manipulates the path the viewer's eye takes when viewing the design for the first time. In this way the designer controls what is read first and in turn, what is understood first. To do this the designer must make decisions and design a hierarchy as to what information should be made most obvious, with the other less immediate elements or information scaled back.

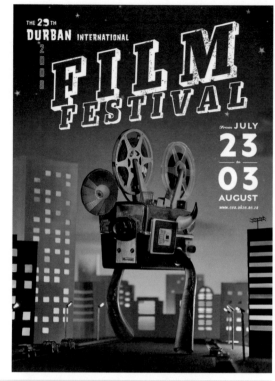

Right:
Promotional poster by disturbance for Durban International Film Festival 2008

Below:
External site identification signage for Constitution Hill precinct by Bon-Bon

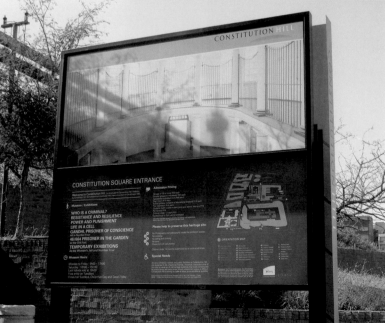

PROPORTION

Proportion describes, by way of comparison, the relative distribution and size of objects, elements or forms in a design. Proportion also determines the overall dimensions of an object's shape, with certain shapes having quite specific associations. A design format that uses a horizontal rectangle is strongly associated with a landscape tradition and would probably be utilised in a coffee table book on photography for example. Whereas a vertical rectangle would most likely be employed in a poster design or as a magazine format due to the association the rising form has with architectural metaphors like windows and doors. Within the composition itself different proportions produce different kinds of balance or symmetry. These relationships aide in creating visual emphasis, dynamism, solidity, depth and variety.

Below from left:
Just another day at the disturbance studio...; poster for Cape Africa platform, designed by Peet Pienaar

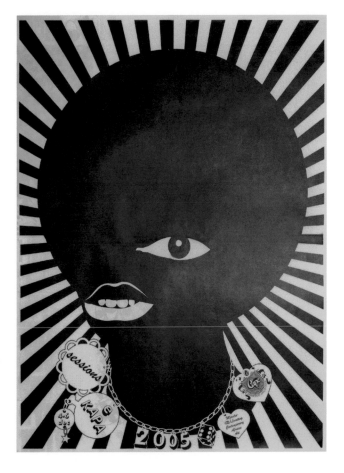

BALANCE

Balance in design terms relates quite closely to the same term as used in physics. When all elements in a design have achieved an optical equilibrium, then the composition can said to be in balance. This effect is created through the relationship between the elements of a design. This relationship can be between objects with similar forms but different positions, or between objects with contrasting forms. A balanced design does not mean one lacking in dynamism or effect, rather it describes a design that is well proportioned, unified and resolved to the point where the overall effect is balanced and visually satisfying. For example, a huge light-coloured object will be balanced in a composition by being adjacent to a small dark-coloured object.

Above:
A poster designed by am i collective for a silkscreen exhibition arranged by Basement Riot

Left:
Identity design for production company Bouffant by Rex

RHYTHM

Rhythm with variation is interesting, without variation rhythm can become a monotonous repetition. Rhythm is a term normally associated with music, and in design it serves a similar function – using the relationships between form and space, rhythm exists in graphic design in the patterns created between the elements in a composition. The inherent movement and flow in a designed composition depend largely on how the elements are arranged in relation to one another. Rhythms can be either regular, static, pulsating, gestural or exaggerated.

Clockwise from top right:
Muskerry 1781 by Scott Robertson & Kim Longhurst, The Curators; Speakerbox online music channel logo design by Code; Lowe Bull, Johannesburg (Nandos) by Scott Robertson, The Curators

COMPOSITION

Composition describes the overall effect of the various principles and elements in a design – whereby the act of assembling, or forming a whole is created by placing together and uniting different elements or ingredients. A composition is the result of balancing, unifying, proportioning and prioritising all the elements in a design, so that a designer can review, edit and refine a design to the point of its completion.

Right:
Poster for missing children, designed by Peet Pienaar

Below:
Poster design by am i collective from a complete campaign featuring flyers, posters, trophy design and animation for the Red Bull BC One Event

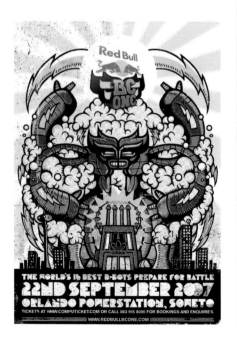

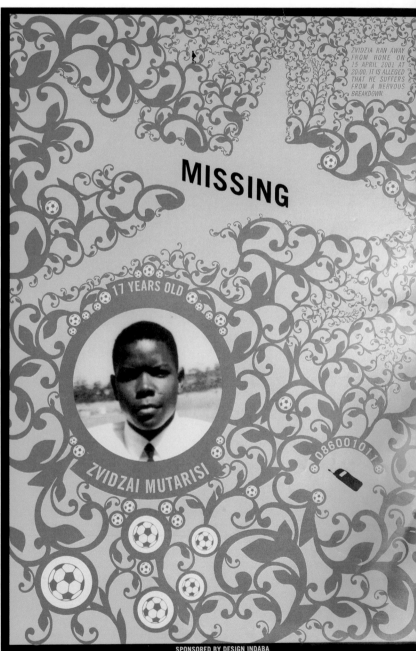

THE GRID

The grid is a basic tool a designer uses to guide the positoning of elements within a composition. As indicated by the title, the grid is an invisible linear formulation that functions as the basis of any designed work. Be it a page, poster, or brochure – a grid or several grids of various forms will be employed to organise how the elements are arranged. Different grids are designed and used according to different types of layout required – a poster will utilise a different one from that of a book, and within a book there might be several grids used throughout, like that shown to the right. A grid consists of both positive (or active) space and negative (or passive) space. The positive space contains the information or content of the design, whereas the negative space acts to hold the contents in place. Active space might consist of text, images or graphic elements whilst the passive space would comprise the margins, gutters, columns, headers and footers that order and structure these informational elements.

Right:
Editorial spreads by disturbance for a 48-page book, *Along the Way*

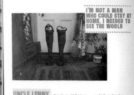

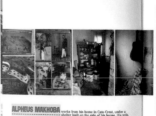

4

4 The Elements of Design

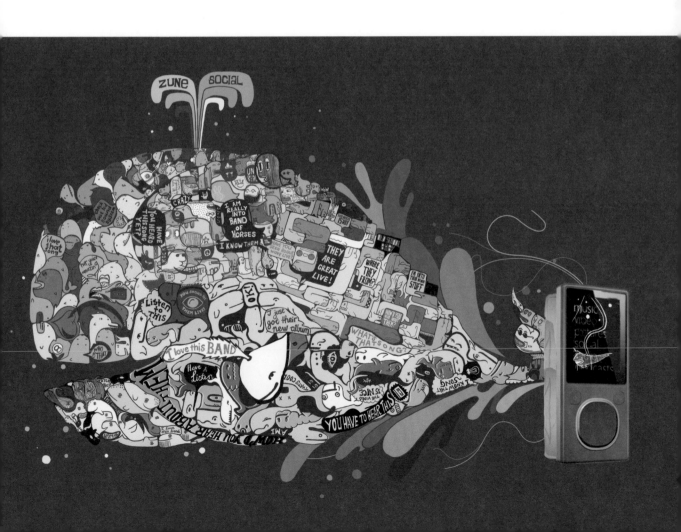

THE ELEMENTS

These are the basic, fundamental components from which all compositions are created. In their most basic and abstract sense they are universal, but they are also very practical. Used in a myriad different combinations, they can produce any book, poster, business card, billboard or design imaginable. This chapter intends to outline these building blocks of design and by reducing them to their most elemental, you can learn how designs are constructed – what their ingredients are. When understood through these means, you will see that graphic design is almost always the sum of its relative parts. For an extended outline of *Typography* and *Colour* see Chapters 7 and 8 respectively.

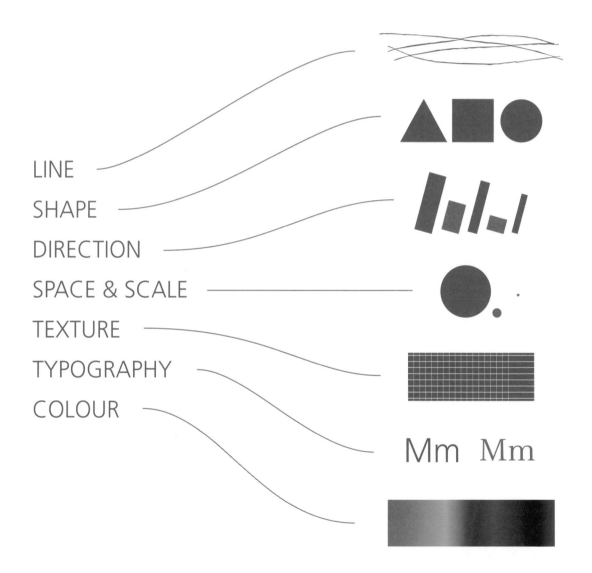

LINE

SHAPE

DIRECTION

SPACE & SCALE

TEXTURE

TYPOGRAPHY

COLOUR

LINE

A line is simply the distance between two points, whereby the shortest distance forms a straight line. It is one-dimensional, and as such has only length and width to describe its parameters. Line is the most basic, and probably the most familiar, of all the elements. We have all, since we were small children, created compositions by drawing lines on paper, in the sand or on chalkboards. Our handwriting too consists purely of shaped lines formed from memory. It is this kind of mechanical movement that creates lines, which our eyes follow and in turn, decipher as language and meaning. This minimum of effort to create volumes of expression is unique to the values of line, whether in a drawing, an illustration, handwriting or a graphic mark.

Line is capable of almost infinite variety. As indicated by the small number of examples on this page, lines can be straight, wavy, broken, multi-layered and even formed of a series of dots. Their character, meaning, shape, value and texture largely depend on what tool or process was used to create them. Apart from physical lines in space, a line can be indicated through the accurate alignment of elements on a page – if your heading, body copy, illustration and footer all align left, then there is a clear indicatation of an invisible line tying them together. Much like colour, lines can create quite specific emotional responses in your audience – a wavy, bouncy line has an inherent youthful and happy character, whereas a thick, straight line has quite a serious and sobre feel to it.

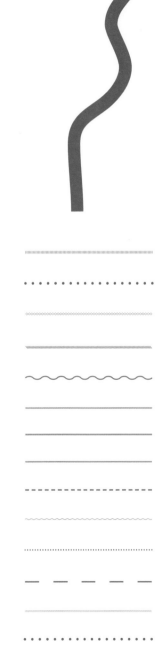

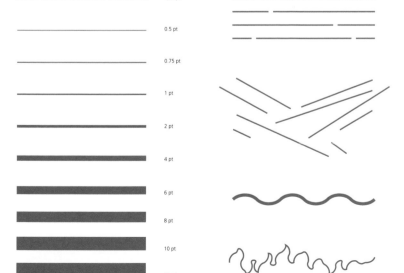

EXAMPLES OF LINE

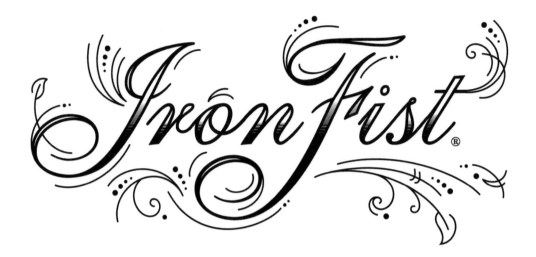

Above:
Logo for Iron Fist by Scott Robertson, The Curators

Right:
Illustration for a feature on extinct languages, published in *Campus Times* (*Mail & Guardian*) by Jason Bronkhorst, Infiltrate Media

Opposite:
Packaging design by disturbance for African Cream CD, a series of Jazz compilations

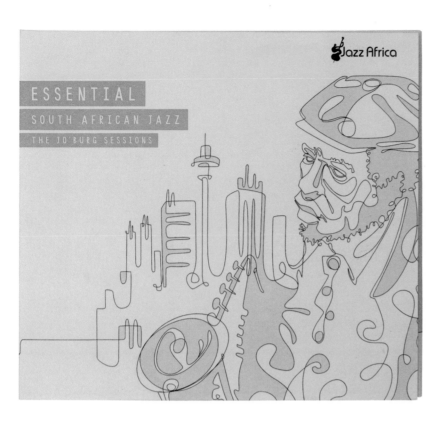

ESSENTIAL
SOUTH AFRICAN JAZZ
THE JO'BURG SESSIONS

Jazz Africa

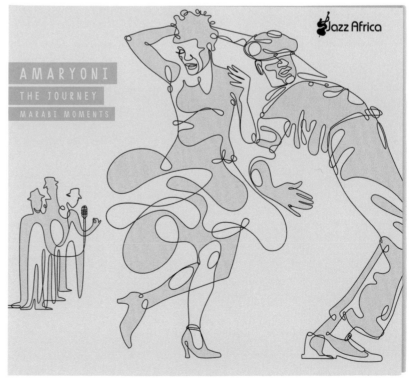

AMARYONI
THE JOURNEY
MARABI MOMENTS

Jazz Africa

SHAPE

In two-dimensional designs, shapes have width and length only, but as you will see below once you enter three-dimensional space, surface and volume also apply to shapes, which are then called forms. Shapes can be understood simply as masses or figures, and the nature of a particular shape determines its relative meaning. For example a large black square would be imposing, heavy, unfriendly, whereas a soft, curved rounded shape could be seen as fun and inviting. Below are several examples of shapes divided roughly into geometric and organic types. Shapes exist within a field – that is within a page design, poster layout or illustration – and as a result they define and occupy the space around them. Positive space is the area occupied by the shape sitself, while the negative space is the area around the shape. Defining and articulating both when designing is vital to maintain harmony, composition and white space.

Surface
The area covering an object or the outside of a volume or mass is described as its surface. This can take the form of a single continous covering like a flat sheet or a series of interconnected geometric or organic shapes or a modular multifaceted covering like that illustrated to the left. In this sense a surface is understood to have only two-dimensions, namely length and width.

Volume
A space defined by its edges containing nothing is a volume. The cube illustrated to the left has eight vertices (eight points where the edges converge) that define its volume. From the angle this cube has been drawn we can see only seven vertices because the drawing is understood to represent a three-dimensional object, and thus one of the vertices is hidden behind the object's volume.

Opposite: Stag Night Mare by Givan Lötz

DIRECTION

All your design work will have an inherent sense of
direction to it. Whether intentional or not, as a designer
you should be aware of how your composition leads
or directs the audience's eye. The angle of type, lines,
graphic elements and the subject of photographs all
direct the viewer's eye, and impact on the general mood
of your design. Whether these different directions are
horizontal, vertical or oblique, each have their own
emotive associations. A strong horizontal direction has
a stable, secure and quite traditional feel to it. Whereas
a dominant vertical direction promotes a sense of
order, activity and sequence. Oblique angles are usually
suggestive of dynamism, movement and energy.

SPACE & SCALE

Much like volume describes an object, space and scale
describe the size and proportion of an environment,
book, poster design or a logo. Scale refers to the
physical dimensions of an object or format. An A4
piece of paper is smaller in *scale* than an A0 poster. If
you were to then put that same A4 paper on top and in
the middle of the A0 poster, the *space* around the A4
would be large.

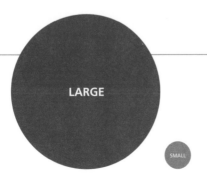

LARGE

SMALL

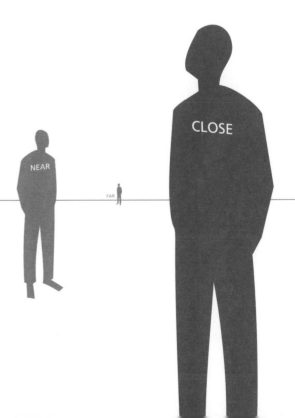

NEAR

FAR

CLOSE

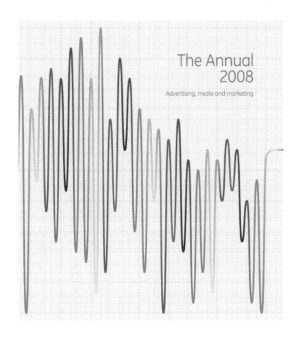

The Annual
2008
Advertising, media and marketing

Above left:
Editorial illustration by am i collective for *GQ Magazine*

Above right:
Editorial design for *The Annual 2008*, a publication by Jeremy Maggs and Future Publishing that provides a snapshot of the advertising and media industries

Left:
Illustration for a story on South Africans emigrating, *Sunday Times Lifestyle* cover by Jason Bronkhorst, Infiltrate Media

Below:
Illustration for a story on women becoming more powerful in business, *Sunday Times Magazine* by Jason Bronkhorst, Infiltrate Media

TEXTURE

Texture describes the surface quality of a material, shape or object: rough, dense, fine, coarse, smooth, glossy or matte. Texture can also describe the grain of a photographic film, the texture of an oil painting or the 'tooth' in a certain type of paper. Physical texture is the kind you can actually touch and feel – the raised ink on a business card, foil block or a paper emboss are all elements that can be described in terms of how the surface of the paper has been altered or physically feels to the touch. The illusion of physical texture, on the other hand, is visual texture and is created either digitally or achieved through the medium you choose. 'Noise' is often used to describe grain or texture in a photographic image. This can be achieved in Photoshop or in camera through the use of a very grainy film. Textures are often used to give print jobs a tangible, tactile quality and digitally they are employed to artificially age or distress an image to create a greater sense of mood, heightened realism or simply for the sake of an interesting texture.

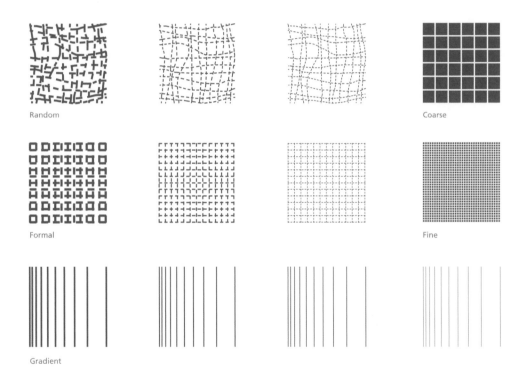

Random

Coarse

Formal

Fine

Gradient

Light

Heavy

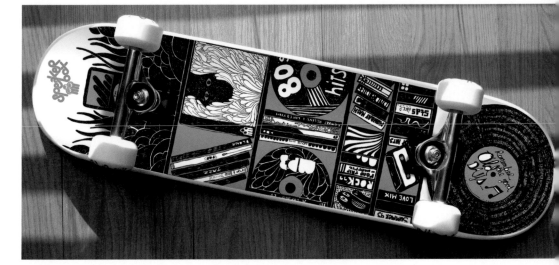

Above:
Photograph by Mia
Ziervogel of a paper
sculpture by Joh Del

Right:
Speakerbox promotional
skateboard deck; design
and illustration by Code

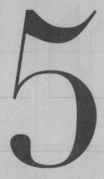

5

Opposite:
Dirty Sanchez by Scott Robertson, The Curators

A Twelve-Step Programme; Case Study One & Two

THE DESIGN PROCESS
A TWELVE-STEP PROGRAMME

DIALOGUE	1	Listen carefully to your client's brief, and make certain you understand it.
STRATEGY	2	Clearly map out the problem you have to solve and/or define the scope of the task you have to deliver on.
ADMINISTRATION	3	Make sure your quote or cost estimate for the job is signed off and any relevant deposits have been paid before commencing work.
RESEARCH	4	Know your client's material better than your client does.
INSPIRATION	5	Define and understand the essential values of the task – both positive and negative.
RESEARCH	6	Extensively research relevant and allied fields.
CREATIVITY	7	Communicate the required message efficiently through your concept and design.
CREATIVITY	8	Refine this message so that nothing can be added or removed from it.
COMMUNICATION	9	Present your efficient, designed message to the client. Direct, manipulate and control this delivery.
DIALOGUE	10	Negotiate any issues, changes or concerns the client might express.
CREATIVITY	11	Deliver a final concise message for the client that hopefully you can both believe in.
ADMINISTRATION	12	Make sure you get paid.

Throughout the design stages detailed on the opposite page, be transparent about your processes, whilst guiding and actively directing the client through them. Design is essentially opinion-based, but your control of information and communication both manipulates and manages your client's expectations and responses substantially. Never show a client too many options of a single design: three versions is usually the maximum, any more than this and they tend to be overwhelmed and struggle to make a choice. If there is a version of the design that you are not 100% sure of, then don't include it in your presentation to the client. Or if you are worried about a client's reaction to certain colours in your designs, then show only black and white versions of a logo, once they are happy with the design's silhouette, form, typeface and icon then move onto the colour knowing that you are halfway there.

Create a concept or an idea or even a series of related ideas that your design will build on. These ideas should closely relate to your client's original brief and their required message.

Have a clear understanding of the market, context and environment you are working in. Avoid following fashion or copying historical design solutions. Focus instead on refining and articulating your concept, message or idea, and designing this information so that these elements are effectively and clearly communicated.

Know and respect your audience. Your design is for them. It is designed by you for others to interpret and use. As result, avoid making decisions that are based purely on personal preference or taste.

Communicate your concept; don't simply decorate it with unneccessary visual gimmickry. If a formal element is included in your design solution purely because you think it is cool or trendy, then odds are you should remove it and focus instead on what core values relate to effectively communicating your concept. Decoration like this can detract from your message and also tends to date very quickly.

Choose colours in your design for specific reasons, not simply on a whim. When it comes time to present your designs to the client it is going to be very difficult to motivate for the inclusion of certain colours if you chose them totally randomly and without thought as to how they relate, how they will be reproduced across various formats and what emotional associations these colours might produce for your client and their audience.

Create an efficient, unified and self-contained voice for your concept. Use hierarchy, balance and composition to do this. If your audience is confused as to where to start engaging with your design, they will simply give up and move on.

Recognise the value of white space and negative forms. Don't clog your design with all available information. Edit your message, and edit your concept down to its bare essence.

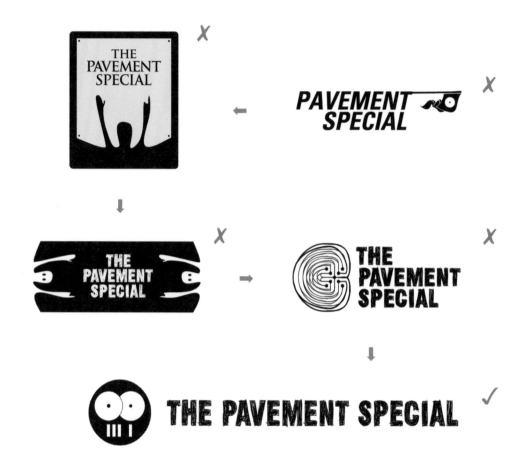

On this page are several logos for a personal project I started in 2007, namely an independent music magazine. After a series of discussions the first four logos (starting from top right) were rejected by my partner in the project and myself for several stylistic reasons. The last logo was finally chosen and continues to be used today. On the landing page for this chapter are twenty-two logos designer Scott Robertson, AKA Dirty Sanchez, produced for himself. Part stylistic exercise, fun and good practice, fundamentally all these logos represent different choices, often each as valid as the next. Whether realising a personal project or a job for a client, the design process is always dominated by choices. What colour? What font? What look and feel is right? Does it work better with the line thicker, or is the thin one better? How will the logo reproduce on the web versus in print? Does it work with the client's other partner brands? During the design process you will ask yourself a million questions and will have to make a million decisions along the way. Hopefully the ones you make will be correct given the circumstances and the nature of the project. If not, then it is literally back to the drawing board and you will have to think up a new solution. The worst part is this might have nothing to do with your decisions, the client might simply just not like it, and you can jump through hoops and pull rabbits from hats but nothing will change that. On the previous page is outlined a twelve-step programme to hopefully survive this process. If you follow its logic it should stand you in good stead, but you must remember that it is an ideal and does not reflect the myriad of complexities, variables and conditions that any given design project might generate. If all else fails, trust your instinct.

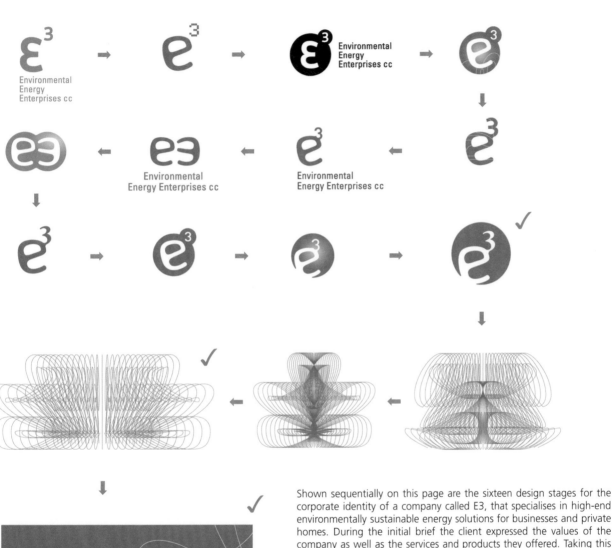

Shown sequentially on this page are the sixteen design stages for the corporate identity of a company called E3, that specialises in high-end environmentally sustainable energy solutions for businesses and private homes. During the initial brief the client expressed the values of the company as well as the services and products they offered. Taking this information I researched existing identity solutions for similar and allied corporations. This was coupled with a breakdown of the client's brief. From this three dominant themes emerged relating to the identity's core values, namely advanced technology, a sincere ethos of environmental sustainability and the dynamic production of energy. Taking these values, the initial designs experimented with how the formal structures of the E and 3 characters could interact and live together. Two separate colours were used in the beginning stages, the blue green to indicate technology and the green for the environmental ethos. Ultimately the green was chosen, and this was coupled with a circular holding device. Once the logo was resolved, the corporate identity called for a dynamic secondary device to complement and activate the brand. Several line graphics were developed based loosely on the wirecoil of a lightbulb, before one device was selected and apllied to the business card as shown to the left.

6

Opposite:
Self-initiated promotional design by Code, featuring airline
and destination stickers for 'Client of the Year' gift

6 Tangible Examples

Corporate Identity; Corporate Stationery; Promotional Design; Editorial
Design; Design for Social Responsibility; Exhibition Design; Self-Initiated
& Personal Projects; Illustration

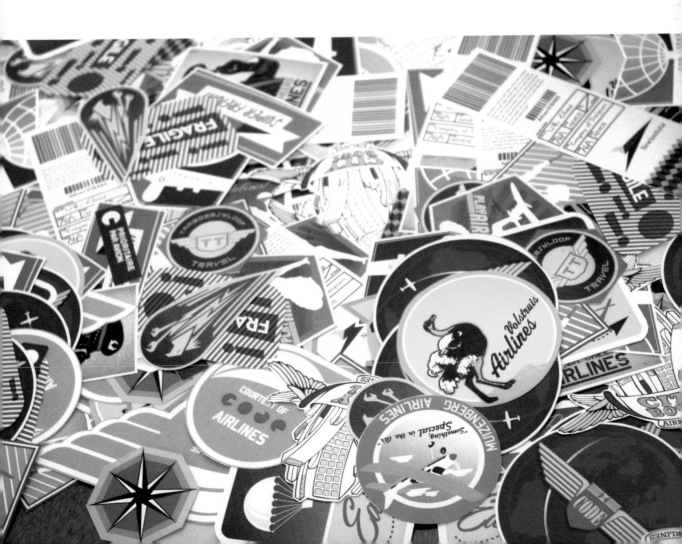

CORPORATE IDENTITY

This category concerns conceptualising and designing a business or an individual person's visual representation of themselves to their customers in the marketplace. Often a client will come to you with a plan or strategy for a start-up business and very little else. It could well be your job to generate a name for their business, followed by a logo, followed by a company slogan or strapline, and onto the full roll out of the corporate identity (or CI as it is commonly called) that includes the breakdown and appropriate use of the brand elements, the specific typeface chosen, colour specification and uses, as well as slogan application. The design of these elements would be included in your fee for the corporate identity execution, whilst a document outlining exactly how these elements should be used (called a Corporate Identity Manual) is usually something

you would charge extra for – dependent on the size and nature of the business you're dealing with. Remember that a corporate identity is used to create a consistent image associated with a specific company, so when you are in the design phase be aware of how the different elements within the logo can be used in the full CI. Namely how a graphic icon, or line graphic or colour system can be used on all the stationary elements, the company website, staff uniforms, packaging, vehicle signage, and physical signage. Often the logo is accompanied by a purely graphic icon or device that acts as a visual avatar or symbol for the company. Think here of the wavy ribbon below the Coca-Cola logo, or the tick icon of the Nike brand – both of these elements do not contain the company's name but act as a visual shorthand for it.

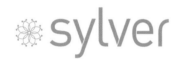

From left:
Sylver brand identity by Fever Identity Design; Matt Black by Scott Robertson, The Curators; Three by Four by Fever Identity Design

From left:
Basement Publishers logo designed by Jason Bronkhorst, Infiltrate Media; Kitchen Confidential brand identity by Orange Juice Design for the Mr Price *Home* range; Left logo by Fever Identity Design

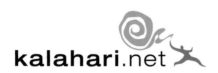

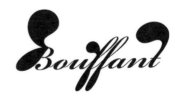

From left:
Brand identity for NASPERS online-bookstore kalahari.net by Orange Juice Design; The Curators – Kim Longhurst, The Curators; Bouffant brand identity by Rex

Dirty Sanchez

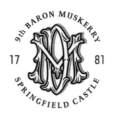

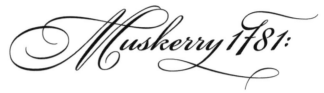

MUSKERRY SEVENTEEN EIGHTY ONE

AMARIDIAN

Top: Dirty Sanchez by Scott Robertson, The Curators
Above: Amaridian brand identity by Fever Identity Design
Right: Muskerry 1781 by Scott Robertson & Kim Longhurst, The Curators
Below left: Matchboxology for Levi's Original Music by Scott Robertson
Below right: A complete campaign design featuring flyers, posters, trophy design and animation by am i collective for the Red Bull BC One Event

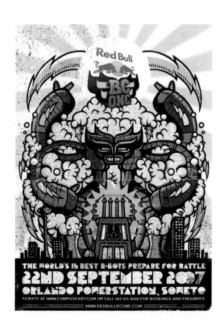

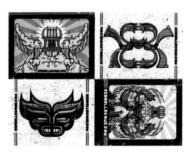

CORPORATE STATIONERY

Usually while you are designing the logo for a client you will, to varying degrees, also be thinking of how it will translate into the full corporate identity applications. Avoid using more than three colours (maximum) in your logo design as it will have a cost implication when it comes to printing the corporate stationery. For optimum colour consistency and print quality, business cards, compliments slips and letterheads are printed as spot colours. This means the printer does not convert your specified Pantone colours in your design artwork to four-colour CMYK values but rather mixes your specific colours before printing and runs each colour as a pre-mixed solid colour, each on one litho plate. As there is only one plate per colour your registration, colour value and colour consistency are all improved. Also if you look very closely at a single-colour print and a four colour print job you will see the dots and colour separations quite clearly in the four-colour process but not in the single colour one. Once

your client is confident to go ahead with the brand identity and slogan or just the identity you have designed, you will be tasked with implementing this across the various stationary elements. Business cards, letterheads and compliments slips are often the cheapest and most effective marketing tools a new business has. Along with a beautifully and intelligently produced identity, the design and print quality of corporate stationery speaks volumes about the calibre of business being represented. It is your job to offer consistent, legible and well-produced solutions for your client across their CI. You can also experiment to a large extent with this category, based in part on the nature of print media itself and also because in an increasingly saturated marketplace coupled with an increasingly media savvy and jaded customer, businesses and clients should be encouraged to look for less conservative approaches to making a difference in such a market place and to stand out.

Below:
disturbance stationery – business cards and compliment slips

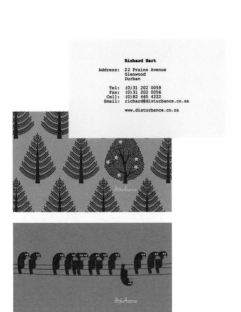

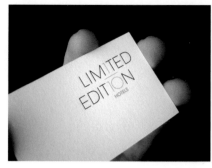
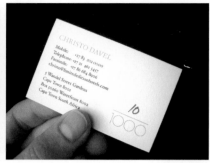

Above: Corporate identity and stationery design by Code, for Limited Edition Hotels – business card and compliments slip

This page:
Business cards, envelopes and an A4 folder by Fever Identity Design for Amaridian, a gallery in New York City showcasing South African art and craft

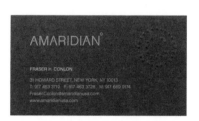

PROMOTIONAL DESIGN

This is quite an open description for a category that could apply to anything from an invitation to a party, or a special offer at a particular business, or a free gift used to market a company or a poster for a specific event. Often there is considerable scope here for both creative concept and execution, with the idea behind the promotion often driving the creative execution. Humour often plays an important role in promotional work. This is partly because you have a narrow window of opportunity to make an impact on your audience. Your principle goal within

this category is to manufacture desire, and much like advertising the event or product you are promoting on behalf of your client needs to have the effect of representing something your audience wants, buys into and remembers. To achieve this you have to communicate your message clearly and easily, either through the legibility of the copy on a poster, or in the high production values of the brochure you have designed for your luxury hotel client, for example.

Right:
Design and illustration of a promotional mailer campaign 'Broking For Good' by CODE for Noah Financial Innovation

Opposite:
Event poster design for TBWA by am i collective

Below:
2002 self-promotional desktop calendar by disturbance

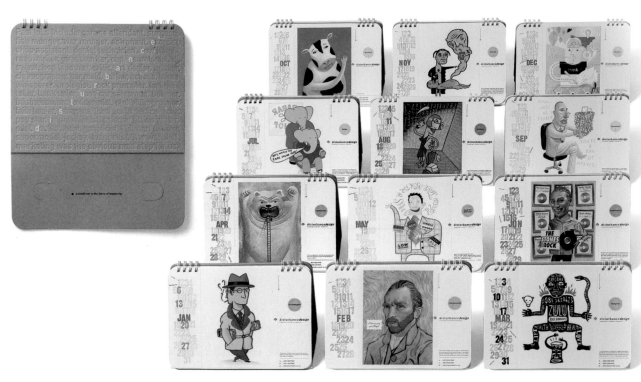

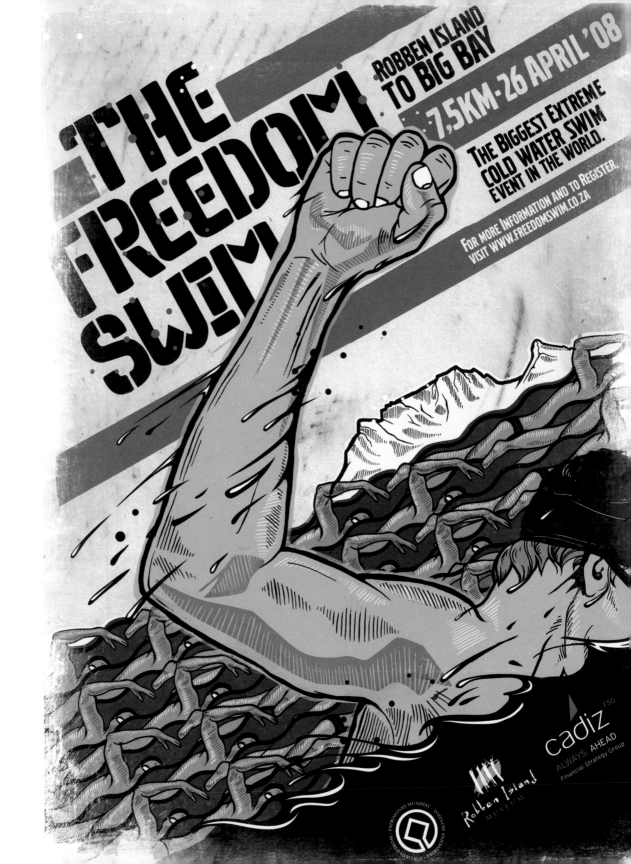

EDITORIAL DESIGN

A highly specialised skill set, editorial design concerns the production of books, magazines, brochures, newspapers and numerous other printed publications. This category can utilise nearly all spheres of the graphic design canon – everything from page layout, to typography, picture editing and DTP (desktop publishing), to art direction, illustration, composition and even the information architecture of how a reader systematically moves through the publication. Learning the intricacies of this discipline takes time and lots of attention to detail. Design tools like style sheets (typographic formats for particular copy applications like headings, body copy or captions), an intelligent grid system implemented from the outset of the project and a methodical approach help enormously in this category. So too does a strong understanding of your material. It is very difficult to design a whole publication if you have not come to grips with

what it is about. The style and tone of a dedicated architecture magazine is going to very different from that of a literary quarterly – understand whom the publication is for and how it is to be used. Designing a language textbook that uses four-colour printing throughout is going to be very costly and probably quite unnecessary. So too is designing a high-end fashion magazine the size of a postcard – it just doesn't really make sense. A useful way to develop this skill is to produce a printed version of your portfolio: with your own design work, curriculum vitae, relevant references and contact details you have the basic ingredients for a dedicated publication. This publication can be something you produce for applying to design schools, a full-time job or an internship and can be updated and developed over time as your experience level and portfolio grows.

Right:
The Big Bad Bitterkomix Handbook published by Jacana, designed by Orange Juice Design

Below:
Cover design by Kim Longhurst of The Curators for Echoing Green Press

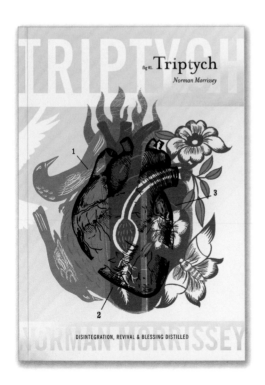

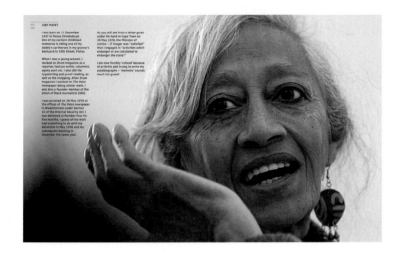

I was born on 27 December 1937 in Fietas (Vrededorp). One of my earliest childhood memories is riding one of my daddy's carthorses in my granny's backyard in 15th Street, Fietas.

When I was a young woman, I worked on Drum magazine as a reporter, feature writer, columnist, agony aunt etc. I also did the typesetting and proof-reading, as well as the stripping. After Drum magazine I worked on The Voice newspaper doing similar work. I was also a founder member of the Union of Black Journalists (UBJ).

I was arrested on 29 May 1978 at the offices of The Voice newspaper in Braamfontein under Section 10 of the Internal Security Act. I was detained at Number Four for five months. I guess all my work had something to do with my detention in May 1978 and my subsequent banning in December the same year.

As you will see from a letter given under his hand in Cape Town on 20 May 1978, the Minister of Justice – JT Kruger was "satisfied" that I engaged in "activities which endanger or are calculated to endanger the state?"

I am now forcibly 'retired' because of arthritis and trying to write my autobiography – 'memoirs' sounds much too grand!

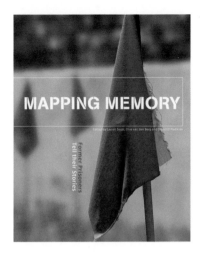

MAPPING MEMORY

Edited by Lauren Segal, Clive van den Berg and Mandla Madikwa

Former Prisoners
Tell their Stories

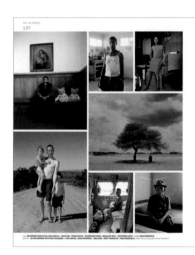

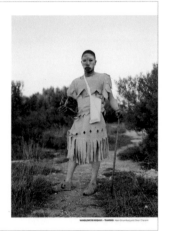

Above:

Mapping Memory: Former Prisoners Tell Their Stories, designed by Carina Comrie and published by Constitution Hill (spread & cover)

Left:

Number Four: The Making of Constitution Hill, designed by Carina Comrie and published by Penguin (spread)

Below:

Editorial design by disturbance for a 48-page book, *Along the Way* (cover & spread)

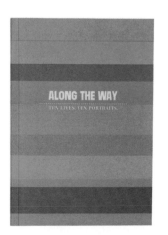

ALONG THE WAY
TEN LIVES, TEN PORTRAITS.

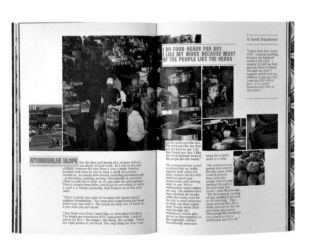

A Good Business

I DO FOUR HEADS PER DAY, I LIKE MY WORK BECAUSE MOST OF THE PEOPLE LIKE THE HEADS

DESIGN FOR SOCIAL RESPONSIBILITY

In the introduction to this book we briefly looked at the impact a designer has on the material reality of the world we live in. This category, Design for Social Responsibility expresses that impact best. As a designer you have a unique platform to enable worthy causes and communicate important issues across environmental, socio-economic and political spheres and in so doing bring public attention them. The 'feel good' factor of designing for socially responsible causes should not be underestimated, as it allows you as a designer to transcend merely economic and professional motivations, to also gain

ethical and humanitarian currency. Design work within this category is quite broad, and might include work for public efficacy groups, environmental concerns, charities, non-governmental organisations (NGOs), protest, activism or even pro-bono work. It is the capacity for lateral thinking, concept creation and flexibility that makes designers ideally suited to transform out-dated modes of production and social paradigms as well as inventing new, more sustainable, intelligent and responsible means of production, communication and ways of doing business within the advanced capitalist model.

Opposite:
Poster artwork by Kudzanai Chiurai from *ONE VOTE* exhibition at DOKTER AND MISSES, 27 June 2008. This work was part of a body of limited-edition poster artworks by Chiurai, protesting against the one party ballot for the 2008 national elections in Zimbabwe. Image courtesy the artist and DOKTER AND MISSES.

Right:
Matchboxology for Levi's CD4 logo designed by Scott Robertson, The Curators. The music compilation album *CD4* was released by Levi's Originals, a non-profit organisation established by Levi's South Africa. Sales of the album benefit The Treatment Action Campaign (TAC), a charity and lobby group for the treatment of people with HIV in South Africa.

Below:
First Chapter Series published by Oak Tree Press, with cover by Flow Design. This series features special editions of Booker Prize-winning novels in the form of numbered and signed first chapters accompanied by original artworks by South African artists. Funds raised from the sale of these books are used for the treatment and support of children living with HIV/AIDS in South Africa. Authors include J.M. Coetzee and Nadine Gordimer.

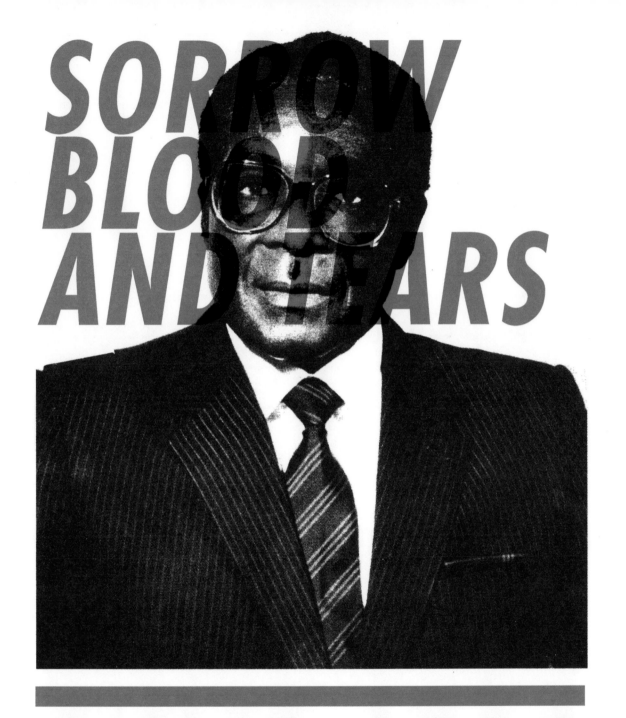

SORROW
BLOOD
AND TEARS

SINCE 1980

EXHIBITION DESIGN

This category is a very exciting and interesting one, but it is also quite a niche skill in this country. It can include everything from the logo design for the exhibition, through to the catalogues that accompany it, to promotional posters and invitations. That is without even including the design of the exhibition itself. Certain category-specific rules and norms apply. These often concern the ergonomics (the study of human movement) of how people use, interpret and interact with the exhibition. The average eye-level height for exhibition design is 1.65 metres from the ground: if large bodies of text are higher than this the average person will struggle to view the content, lower and you risk irritating visitors, thus failing to allow easy interpretation. Copy sizes also need to be adequate and sufficiently legible typefaces for ease of reading need to be used – good examples of these are Interstate, Meta, Frutiger, DIN and Helvetica. Understanding how a visitor will move through the three dimensions of the exhibition is also vital as is an adequate understanding of how to optimally produce it – know the limitations of your materials, print processes and installation techniques as these will have a direct impact on the design solutions you generate.

1: Exhibition design by Bon-Bon in collaboration with the Trace curatorial team, for *Gandhi: Prisoner of Conscience* at Constitution Hill, Johannesburg

2 & 3: Installation views of the exhibition *Number Four* at Constitution Hill, Johannesburg. Design by Bon-Bon in collaboration with the Trace curatorial team

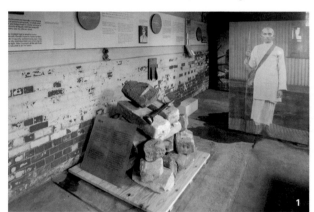

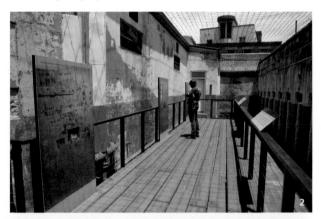

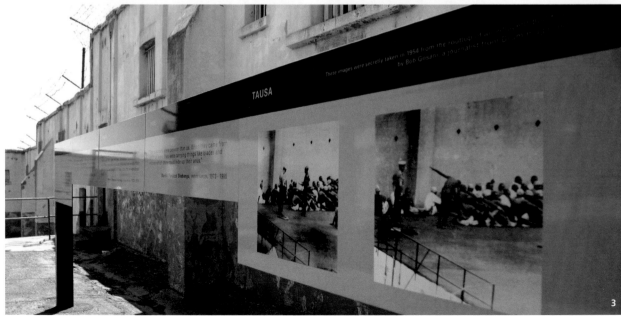

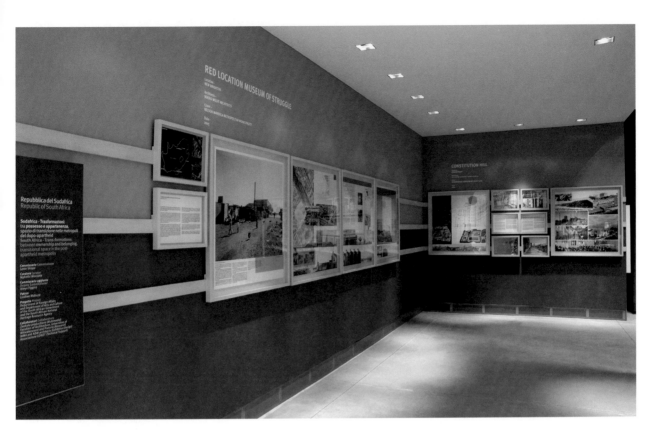

On this page is the exhibition produced for the South African national exhibition at the 10th Venice International Architecture Biennale designed by Fever Identity Design. The primary feature of the design utilised numerous 1m² framed print artworks that formed the content of the exhibition, titled *Between Ownership and Mobility*. These large information graphics were accompanied by smaller, A3-sized framed location and orientation maps as well as descriptive texts. As the exhibition toured extensively, all these framed elements were hung on a three-tier rack system that allowed the modular framed units to be installed and deinstalled easily as well as arranged in a multitude of different configurations, depedent on the thematic narrative being told and the specifics of each exhibition venue.

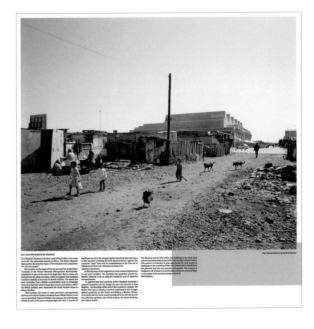

SELF-INITIATED & PERSONAL PROJECTS

As we can see from the examples shown in this section, South African designers have a healthy respect and active enthusiasm for producing work of their own, i.e. without a client. Designers like Garth Walker and Peet Pienaar have gained considerable profiles and opportunities through the projects they have initiated themselves. These are often borne of a desire to change things – to produce publications that they feel are much needed and to offer scope for experimenting and communicating. Disturbance has produced a sizable monograph on their work to date that's not only an invaluable contribution to the local design fraternity but is also an entertaining and quite whimsical book of ideas, experiments and tangible examples. These self-initiated projects very often take the form of publications, for as a designer there are few things more appealing than a magazine or a book all your own to fill with whatever you choose. For a young designer with few clients, millions of ideas and no budget, self-initiated publications or personal projects are a great way to develop your skills and experiment with design. These projects can be used as portfolios in themselves when applying for jobs, internships or to design schools, and are a good way to grow as a designer.

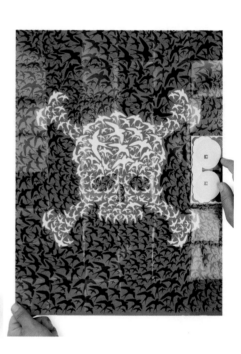

Above: *Afro Magazine* 1 & 2, designed and published by Peet Pienaar and Heidi Chisholm. The magazine is dedicated to investigating and showcasing pan-African arts and culture

Below: **Self-initiated publication titled *Sheet* by disturbance, from left are issues 15, 13 and 9**

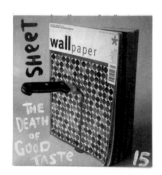

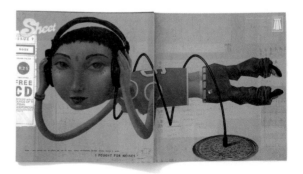

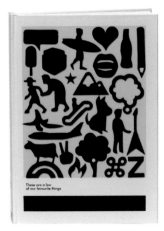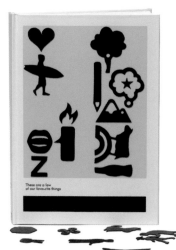

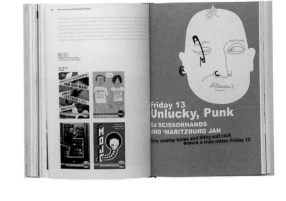

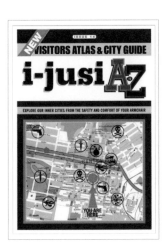

Above:

240-page monograph on the work of disturbance, *These are a few of our favourite things*, with hard-cover, magnetic graphics (cover & spreads)

Left & below:

i-Jusi magazine published by Orange Juice Design, an iconic design and culture magazine published regularly since 1994 and focused on articulating and developing a distinctly African, and specifically South African, vernacular design language

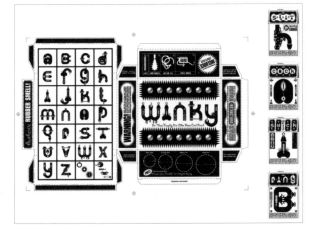

ILLUSTRATION

Often seen in the past as a separate, specialised, but related skill to graphic design, illustration is increasingly part of a designer's core skill and more and more illustrators are working as graphic designers. Many creatives simply shrug off labels, choosing instead to produce illustrations and corporate identities whilst laying out books and art directing photoshoots – such is the nature of the young creative and the direction of the industry itself. The authored, handmade feel of illustration is increasingly sought after, particularly in advertising, as a way of communicating personality and individuality, superseding the previously dominant role of photography. Illustration is, however, still a specialised skill but one that affords a designer a unique opportunity for expression and creativity. In this sense, it is often the closest form of design to the visual arts, and as such requires a creative not only to be inventive and have a strong sense of design but also to posses excellent drawing skills.

Below left:
MTV Base poster design for Ogilvy, Johannesburg by am i collective

Below right:
Packaging design and illustration for production company Humanoid by Joh Del

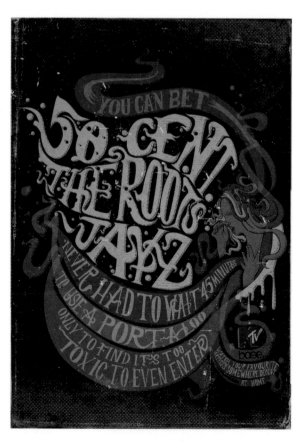

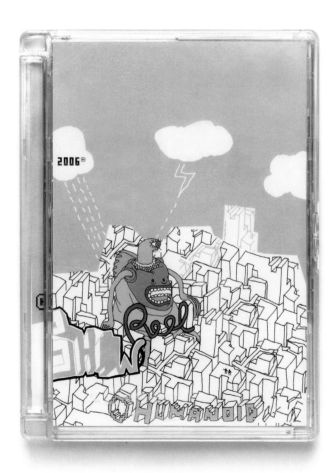

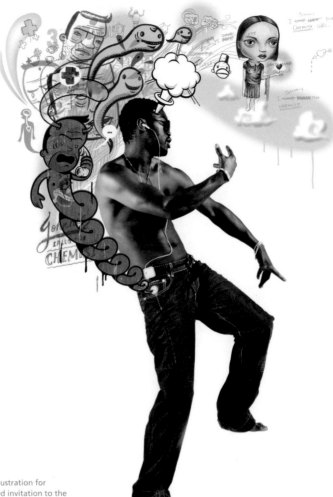

Valentyns
AMANDLA
AMASA
Increase
BARAKA
Promotion
Tell us your Dream
Care
Africa
READING
Profyt

Leftbreak
GHOP
WOOD
CARRY
Water
WHOEVER
Mihogo
JAN VAN HUNKS
Draai
Safety
STOKED
VIVA

Clockwise from top left: A selection of hand-drawn typography by am i collective; illustration for Matchboxology for Levi's Redwire by Scott Robertson, The Curators; an illustrated invitation to the *Verstikland* exhibition arranged by am i collective; *Robotrate* a fictional robot character designed for the iCommons Annual 2008 by Jason Bronkhorst, Infiltrate Media

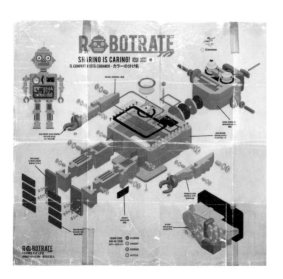

ROBOTRATE
SHARING IS CARING!

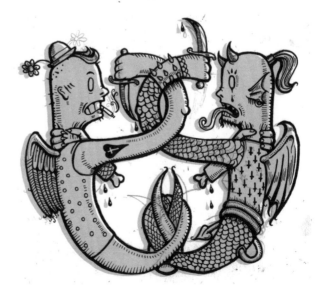

7

7 Typography

Introducing Type; Do's & Don'ts; Typefaces, Letterform, Font Families, Size; Serif & Sans-Serif; Kerning, Masculine & Feminine, Customising Type; Alignment, Leading, Reverse Type, Reading Comfort; Using Type

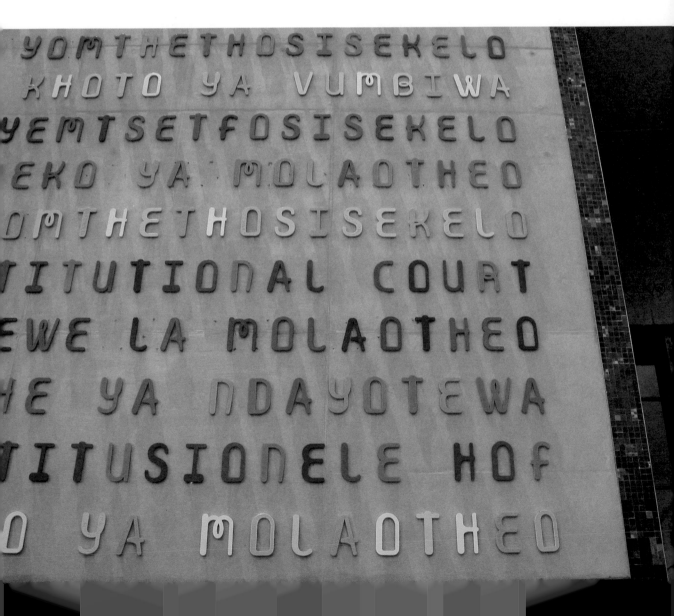

INTRODUCING TYPE

Typographic arrangement should achieve for the reader what voice conveys for the listener.

– El Lissitsky

Each typeface, or font as they are more commonly called, has its own individual texture, personality and tone, and each individual letter its own voice, character and posture. Together they pool into words, which flow into sentences, that pour into paragraphs that torrent into books, catalogues, websites, volumes, libraries, whole archives and complete languages. As in most components of graphic design there are no set rules that govern typography, but a generally common understanding of what works and what does not. Just as for colour, composition or balance, efficient and beautiful typography has tone, shape, form and shade that make a page come to life whilst actively, clearly and enticingly communicating content with an economy of effort that makes us unaware we are even being seduced by the letters, words and paragraphs in the first place. Our eyes just enjoy it, there is no great leap, hard work nor wrestling match with the page to grasp what is being said, sold, told or announced. We just get it. That said, this alchemy takes considerable technical skill, hard work and experience to achieve its own invisibility. This chapter aims to show you certain patterns of successful typographic design; outline and dissect what typography is; provide useful information on how to assemble and manage quantities of copy and show tangible examples of how typography can be successfully used as a graphic, informational and aesthetic tool in your design.

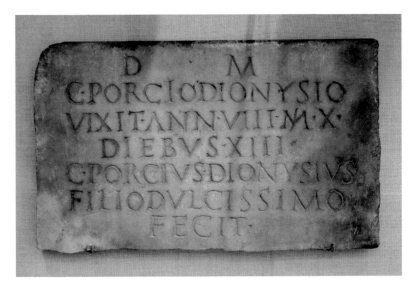

The Ancient Greeks, followed by the Romans, developed and used the first versions of serif typefaces several thousand years ago. Like those carved on this tablet from around 90-100 A.D., versions of these same letterforms continue to be used today.

Roman, Flavian or Trajanic stone tablet, circa 90-100 A.D.

✗ 1. **You should avoid using** more than three (absolute maximum) typefaces in a singular **piece of design. It looks clumsy,** CONFUSING AND visually jarring to use more.

✓ 2. Emphasis within text should be used with the **maximum efficiency**. This allows the emphasis more impact and space to breathe.

✗ 3. Justifed text may aide the composition of a layout or design but should be used carefully to avoid irregularly spaced sentences and words.

✗ F Letters, words and paragraphs should always align to
 O the bottom because vertically running text like that on
 U the left is difficult to read, as it is not how the eye is
 R used to navigating, namely from left to right.

✓ 5. The space between letters (kerning) allows a reader an easy read and gives the text blocks visual harmony.

✓ 6. When typesetting text blocks, use align left the most, as it is the most comfortable and natural way for your eye to read text and make meaning.

✗ 7. AVOID USING ALL CAPITALS IN LARGE BLOCKS OF COPY – IT IS DIFFICULT TO READ AS IT QUICKLY MAKES YOUR EYES TIRED.

✗ 8. Avoid Using Capitals Letters On The First Letter Of Each Word In A Long Title, As This Makes For An Uncomfortable Appearance And Is Difficult To Read.

✗ 9. The text size for body copy should be between 8 - 10 pt. Obviously this depends on what font you are using. Large body copy like this looks clumsy and amateurish.

✓ 10. Typefaces MUST be legible.

DO'S & DON'TS

To the left are ten essential guidelines for using type that will serve you well in your day-to-day life as a designer. Readers are most at ease with visual languages they are used to. Designs that go contrary to normal typesetting practices, i.e. what people are used to, should be used carefully and very deliberately. Rules or formulas for effective typesetting do not exist – either a layout will work or it won't and either you can see this or you can't. Usually when you try to read or otherwise engage with your design you will see and correct any issues with, or errors in, how it effectively communicates. When laying out large volumes of type try to put yourself in the position of the reader; they are mainly interested in gaining the information contained within your design through the easiest possible means. Any hindrance to legibility or confusion of understanding and they will simply move onto the next page, piece of information, billboard or news article and you will have failed at your job.

TYPEFACES

When working with typography choose fonts whose visual associations are appropriate to your content or subject. As a general guide, serif typefaces like Celeste are more traditional and conservative than sans-serif typefaces like this one called **DIN**, which are more modern and hard-edged. Compare the seven typeface examples detailed below. They all have quite different textures, associations and tones. Also look at how these different fonts change in size and length even though they are all set in the same 11 point size. Notice how the Gill Sans Regular has a stronger tone than Celeste, and how the DIN typeface is easier to read than the Rotis Serif. When working with substantial quantities of copy be aware that different typefaces bulk in different ways, that is, they each have a very different visual feel when used in large quantities. A large, quite weighty font like Gill Sans when used extensively can become quite dense, oppressive and uninviting. Perhaps the *Light* version of this font might be better suited for a long feature story. Also if you were producing a piece of promotional design for a young sports brand you probably wouldn't use a more traditional font like TIMES NEW ROMAN for the logo; maybe something cleaner, younger and more fun might be appropriate. Choose your fonts carefully. Beyond the words and sentences they form, their unique character communicates volumes to a reader.

Every typeface has a unique tone that should produce a harmonious relationship between the content's visual character and its linguistic information.
– FRUTIGER LIGHT 45

Every typeface has a unique tone that should produce a harmonious relationship between the content's visual character and its linguistic information.
– HELVETICA NEUE ROMAN 55

Every typeface has a unique tone that should produce a harmonious relationship between the content's visual character and its linguistic information.
– CELESTE REGULAR

Every typeface has a unique tone that should produce a harmonious relationship between the content's visual character and its linguistic information.
– DIN REGULAR

Every typeface has a unique tone that should produce a harmonious relationship between the content's visual character and its linguistic information.
– GILL SANS REGULAR

Every typeface has a unique tone that should produce a harmonious relationship between the content's visual character and its linguistic information.
– ROTIS SERIF 55

Every typeface has a unique tone that should produce a harmonious relationship between the content's visual character and its linguistic information.
– TIMES NEW ROMAN

LETTERFORM, FONT FAMILIES, SIZE

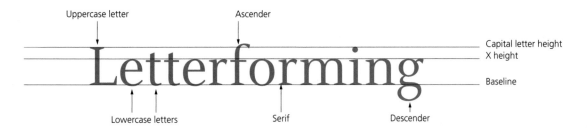

Above are detailed the component parts of typeface letterforms, namely the elements of individually designed letters within any given font.

Frutiger Light 45
Frutiger Roman 55
Frutiger Bold 65
Frutiger Black 75
Frutiger Ultra Black 95

Helvetica Ultra Light Condensed 27
Helvetica Thin Condensed 37
Helvetica Light Condensed 47
Helvetica Condensed 57
Helvetica Medium Condensed 67
Helvetica Bold Condensed 77
Helvetica Heavy Condensed 87
Helvetica Black Condensed 97
Helvetica Extra Black Condensed 107

DIN Light
DIN Regular
DIN Medium
DIN Bold
DIN Black

Times New Roman
Times New Roman Italic
Times New Roman Bold
Times New Roman Bold Italic

In almost all font families* there are variations on the original design that are used for different applications. These variations usually include: italic or oblique; medium or regular; bold, condensed or narrow; extended and light.

* These are the ranges of typeface styles based on a single typeface design.

The unit of measurement used for type size is called a *Point* (or *pt* like below). The height of a lowercase letter is taken from the bassline to the *x height* as detailed above, while the uppercase letters are measured from the baseline to the *Capital Letter Height*. As you can see on the opposite page, fonts that are set in the same point size are not neccessarily the same height in reality. This is because each font has a unique design and behaves in different ways at different sizes.

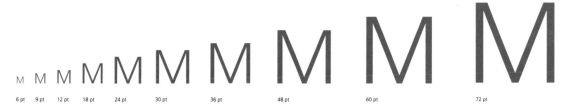

6 pt 9 pt 12 pt 18 pt 24 pt 30 pt 36 pt 48 pt 60 pt 72 pt

This is a serif typeface called Garamond set in 55 pt Regular with 58 pt leading and 0 pt kerning.

This is Garamond Bold set in 9 pt with 16 pt leading and 0 pt kerning.

This is Garamond Semi-Bold set in 9 pt Oblique with 12 pt leading and 0 pt kerning.

Garamond
This is a Geralde Serif from between 1500 and 1600 and is characterised by heightened contrast between the thinness and thickness of the characters. Garamond, named after Claude Garamond (1480-1561), came into wide use from the 1500s onwards.

Serif Typefaces
As we saw in the introduction to this chapter, serif typefaces are ancient in their origins. These faces can be distinguished very easily by the extended lines at the end of each stroke. They consist of five main categories: *Venetian*; *Geralde*; *Transitional*; *Modern* and *Slab Serif*.

This is a sans-serif typeface called Frutiger set in 55 pt Regular with 58 pt leading and 0 pt kerning.

This is Frutiger set in 9 pt Bold Condensed with 12 pt leading and 0 pt kerning.

This is Frutiger set in 9 pt Light with 12 pt leading and 0 pt kerning.

This is Frutiger set in 9 pt Black with 12 pt leading and 0 pt kerning.

Frutiger

Frutiger is a sans-serif typeface designed by Adrian Frutiger in 1975 as part of a directional signage system for the new Charles De Gaulle International Airport outside Paris, France.

Sans-Serif Typefaces

First introduced in 1817, these highly legible typefaces are used extensively in signage, body copy and information graphics. They are divided into three categories: *Grotesque* and *Neo-Grotesque*, *Humanist* and *Geometric*. Frutiger, the typeface above, is a *Humanist* sans-serif due to the organic, almost hand-drawn feel of the design.

LETTER SPACING ✓
LE T TER SPACING ✗

The above illustrates the correct and incorrect letter spacing of two words. Also called *kerning*, this technical term refers to the distance between each character and each word in lines of type. Letters and words should be evenly and carefully distanced to allow ease of reading and for visual harmony in large volumes of copy.

MASCULINE *Feminine*

Different fonts produce distinctly different reponses. As I have mentioned, individual typefaces have unique personalities to them, and just like people they also often have quite distinct genders. Shown above, the font to the left is Helvetica Neue Black 95 and looks decidedly masculine in its iconography. Whereas the font Didot shown to the right, has a positively female feel to it. These distinctions can be useful when designing work for brands that are gender-specific, like a men's sports company or a perfume range, where the choice of specific fonts with specific gender associations can be used to your advantage.

kuka-me ✗ *the tart* ✗
kuka-me ✓ *the tart* ✓

Shown above are two examples that function much like a game of spot-the-difference. They are used here to illustrate both how much and how subtly an original typeface can by customised when designing a logo. The top two examples show the untouched original fonts intially selected by me for possible use in the design of these two separate brand identities. Following a fairly typical series of design stages, the bottom two examples show the single colour versions of the finished logos. In the left-hand example you can see the 'a' was changed altogether, replaced by a character from a totally different font. A number of structural changes were also made to the individual letterforms, which can be seen when comparing the two. In the example to the right a number of subtle but quite effective changes were made to the original typeface design to give it a more playful and friendly feel, in keeping with the nature of the company this identity represents.

This block of copy is left aligned. This means each line of type begins from a single vertical line on the left and ranges according to the text block size.

This block of copy is centre aligned. This means each line of type begins from a single middle point on each line and ranges evenly on both sides of this line according to the text block size.

This block of copy is right aligned. This means each line of type begins from a single vertical line on the right and ranges according to the text block size.

This block of copy is justified. This means each line of type is forced to extend to the inside edge of the given text block size.

When typesetting text blocks, use align left the most, as it is the most comfortable and natural way for your eye to read text and make meaning. Centre aligned has a traditional, and even conservative feel, whilst right aligned is quite difficult to read in large volumes.

This block of copy is left aligned. This means each line of type begins from a single vertical line on the left and ranges according to the text block size.

This block of copy is left aligned. This means each line of type begins from a single vertical line on the left and ranges according to the text block size.

Placing white text on a dark background is called *Reserve Type*. To compensate for the increased difficulty in legibility of the thin font against the dark background, it is good practice to use a thicker, bolder font in this application.

The term *Leading* refers to the space between lines of type measured from the baseline of a character below to the baseline of a character on a line above it. The term originates from the hot metal typesetting process that used lead strips to separate the lines of type.

Each line of this text block is squashed together because the leading is set too tight relative to the font size. X

Each line of this text block is equally and comfortably spaced because the leading is set at a value greater than the font size. ✓

Reading Comfort for volumes of text is determined by the length of the line of text the reader's eye has to navigate. To the right we see three ways of displaying type set at a small size (6 pt). The top orientation is most difficult to read while the bottom one is easiest, because your eye can run along the short lines easily as opposed to getting lost on the long line at top.

This block of copy is left aligned. This means each line of type begins from a single vertical line on the left and ranges according to the text block size. X

This block of copy is left aligned. This means each line of type begins from a single vertical line on the left and ranges according to the text block size. This block

of copy is left aligned. This means each line of type begins from a single vertical line on the left and ranges according to the text block size. X

This block of copy is left aligned. This means each line of type begins from a single vertical line on the left and ranges according to the text block size. This block of copy is left aligned. This means each line of type begins from a single vertical line on the left and ranges according to the text block size.

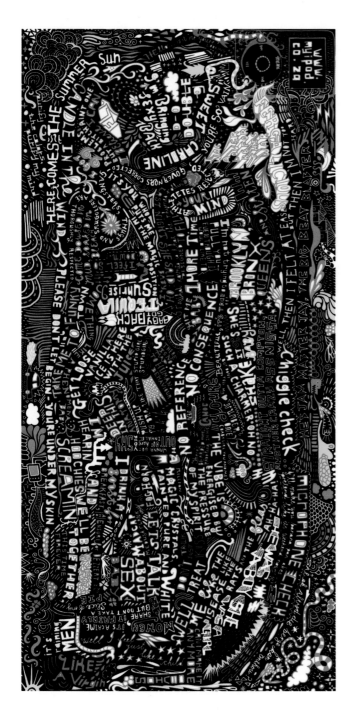

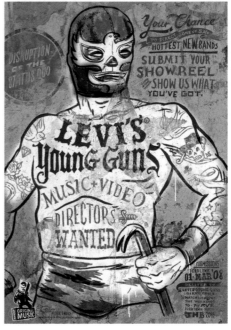

Clockwise from left: **Fold out pack insert poster design for** iPod.co.za by am i collective; Matchboxology for Levi's Young Guns by Scott Robertson, The Curators; environmental design for restaurant, gallery and retail outlet, Home by disturbance

As we have seen in Gregor Graf's digitally altered images and those of Times Square in the *Introduction*, type, copy, fonts and written language are things we see and deal with everyday. They are everywhere. Despite their abundance or probably because of it, the signs, ideas, communications and texts we place in the public realm come with no guarantee that anyone will actually read them or pay them any attention. As a designer your job is principally to encourage the public to engage with your and your client's public communications. This is done by creating attractive, engaging and accessible compositions and designs that the reader or viewer does not have to struggle to understand. The ways of doing this are infinite, but a familiarity with how type works, and a respect for its innate character will work wonders when you use typography to propagate your messages, services, products or ideas.

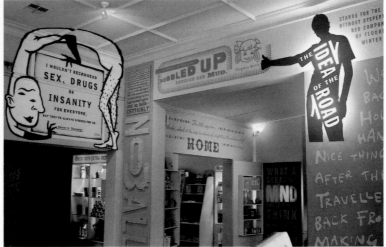

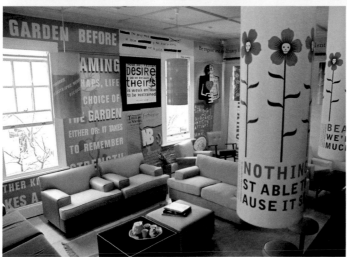

8

Opposite:
Just another day at the disturbance studio...

8 Colour

Introducing Colour; Colour Theory; Screen Display; Printed Colour;
Colour Harmony; The Properties of Colour; Specification &
Reproduction; Using Colour

INTRODUCING COLOUR

In order to use colour effectively it is necessary to recognise that colour deceives continually.

– Josef Albers

The function and role of colour in communication design are complex. Part creativity, part common sense, part opinion and part science, colour is the rare combination of personal preference, theory and fact. Colour is one of the spheres of design practice that produces the most emotive and subjective responses from designers and clients alike. This is based primarily on the fact that colour as a design element operates as unique emotional languages, psychological tools, subjective identities and symbolic relationships. It is also one of the most technical aspects of design. One can spend many hours getting the colour right, both for display use on a screen and especially in print reproduction.

As a designer, you must be familiar with the core components of colour, its numerous modes and relationships and the many ways of applying it. In an increasingly globalised marketplace the designer should also aim to be aware of the social and cultural implications of colour. In South Africa, colours have different meanings for different cultures. In the Zulu tradition the colour *black* signifies both marriage and rebirth in its positive role, as well as death in the negative. In Anglo-Saxon culture *white* is used traditionally for marriage and christenings, whilst *black* is the signifier of death. In Japan the colour *yellow* signifies courage, whereas in the United States, the same colour often signals cowardice.

Colour is a very powerful design tool, and the one closest to emotion and misinterpretation. Sometimes you will find a client totally opposed to a logo or a design based purely on their emotional responses to the colours used. Changing the colour often completely changes their intitial opinion of the work. Treat colour with respect and use it principally as a communication tool. In this way you will be able to argue for its specific use when a client questions your choices. This chapter intends to familiarise you with what colour is; the theory behind it; the different forms it takes; how to manage and reproduce it and finally examples of using it to maximum effect.

THE ELECTROMAGNETIC FIELD

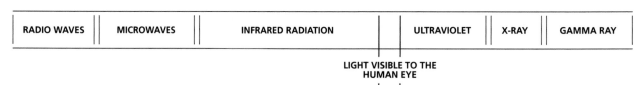

| RADIO WAVES | MICROWAVES | INFRARED RADIATION | ULTRAVIOLET | X-RAY | GAMMA RAY |

LIGHT VISIBLE TO THE HUMAN EYE

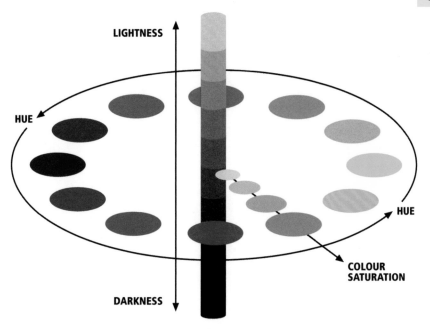

LIGHTNESS

HUE

HUE

COLOUR
SATURATION

DARKNESS

MUNSELL COLOUR WHEEL

Developed by Albert Munsell in the 19th century, the Munsell Colour System is a practical colour theory whereby colour is defined in terms of Hue, Value and Saturation. *Hue* is defined as the shade of colour, i.e. blue or red. *Value* defines lightness or darkness of a color. *Saturation* is the term used to decribe the strength of a colour.

JOHANNES ITTEN

Itten was a Swiss colour and art theorist who taught at the Bauhaus. All of his colour wheels are founded on the primary colours (red, blue and yellow) and feature twelve hues in total. He was most concerned with creating a structural approach to the study and use of colour based on complementary and simultaneous contrasts.

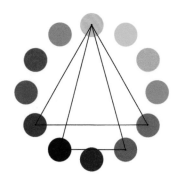

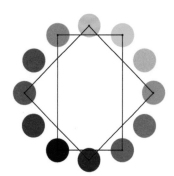

GOETHE COLOUR TRIANGLE

Johann Wolfgang von Goethe believed that different colours were closely linked to certain emotions. Illustrated to the right is his harmonic triangle divided into nine equal parts. The outer three triangles are the primary colours; the secondary colours are formed from primary colours; and the resulting tertiary colours create the innermost three segments.

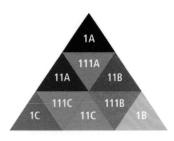

1A
111A
11A 11B
111C 111B
1C 11C 1B

SCREEN DISPLAY

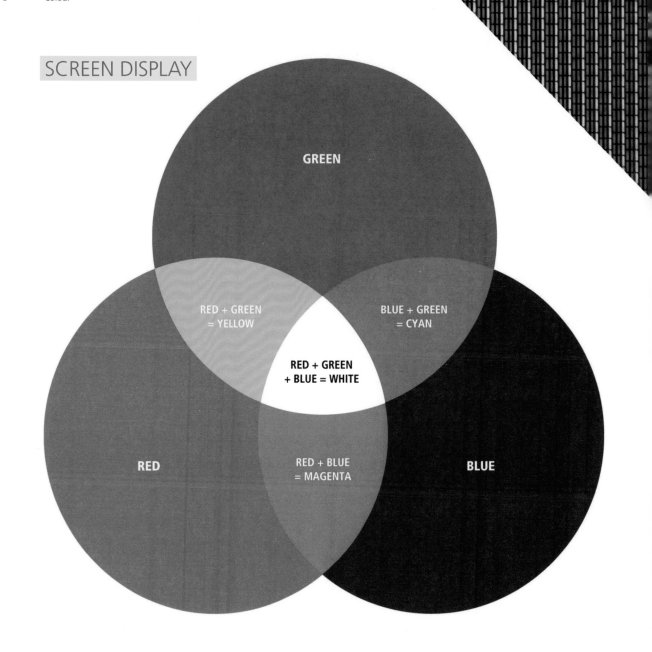

GREEN

RED + GREEN
= YELLOW

BLUE + GREEN
= CYAN

**RED + GREEN
+ BLUE = WHITE**

RED

RED + BLUE
= MAGENTA

BLUE

ADDITIVE COLOUR MIXING (RGB)

Designers working with web design, or any form of design intended for display on an illuminated screen, make use of the Additive Colour process or RGB (Red + Green + Blue). Computer monitors, television screens, digital video and still cameras, scanners and cellphones all use the RGB system to create their display colours. In the light colour spectrum when you combine all three colours (RGB), white light is produced. Hence the name Additive Colour Mixing, because all colours make white. The seemingly infinite combinations of red, green and blue create the millions of colours our eyes are physically able to see.

PRINTED COLOUR

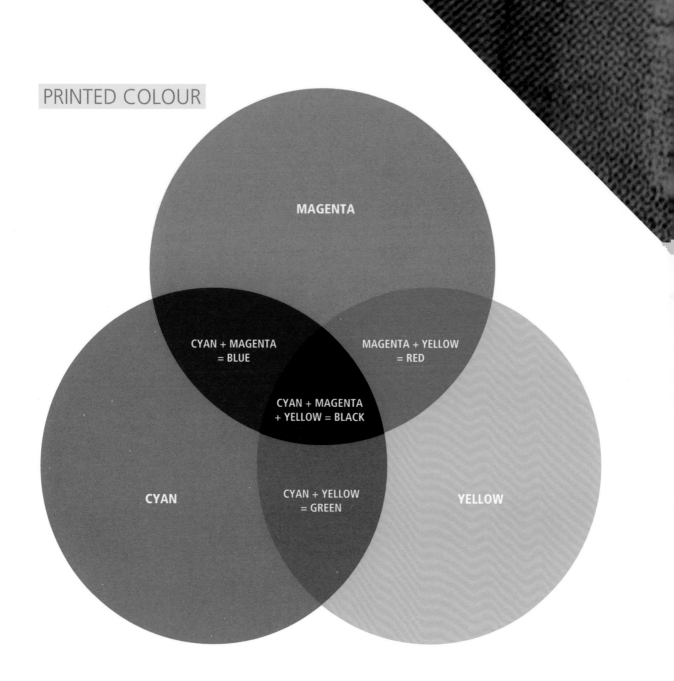

MAGENTA

CYAN + MAGENTA
= BLUE

MAGENTA + YELLOW
= RED

CYAN + MAGENTA
+ YELLOW = BLACK

CYAN

CYAN + YELLOW
= GREEN

YELLOW

SUBTRACTIVE COLOUR MIXING (CMY)

As you can see by comparing the colours represented
in the diagrams on these two pages, in Subtractive
Colour Mixing two subtractive primary colours create an
additive primary colour when mixed together. When three
subtractive colours are combined they produce black,
unlike the additive colours which produce white.

COLOUR HARMONY

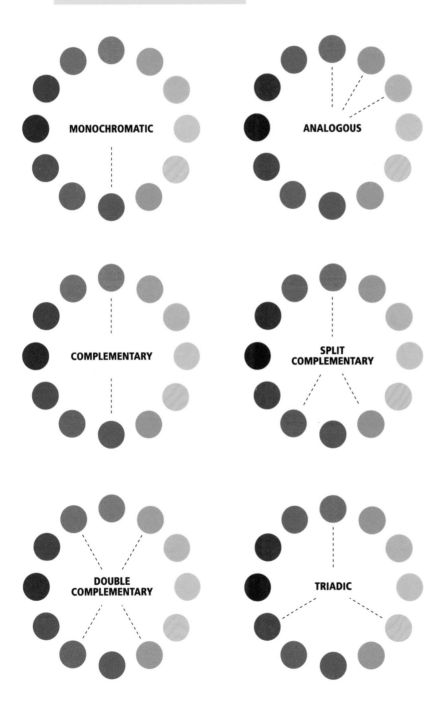

MONOCHROMATIC

ANALOGOUS

COMPLEMENTARY

SPLIT COMPLEMENTARY

DOUBLE COMPLEMENTARY

TRIADIC

MONOCHROMATIC
These are tints or shades of a single colour.

ANALOGOUS
These colour combinations are formed from two or more colours adjacent to one another on the colour wheel.

COMPLEMENTARY
Showing the maximum colour contrasts, these colours are opposite one another on the colour wheel.

SPILT COMPLEMENTARY
These are colour combinations comprising three colours on the wheel spaced directionally evenly from the first colour's position.

DOUBLE COMPLEMENTARY
These colours are created through the combination of four complementary colours.

TRIADIC
These are colour combinations comprising three colours on the wheel spaced directionally evenly from the first colour's position.

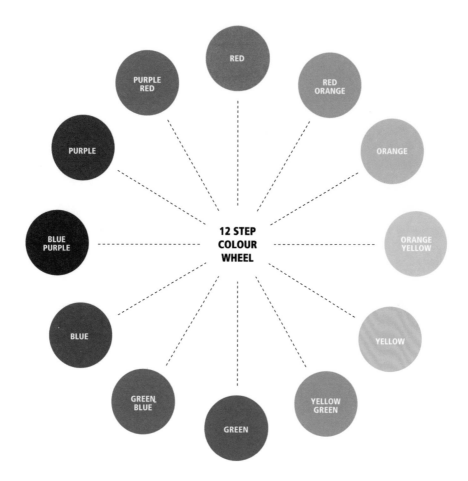

Above is illustrated Sir Isaac Newton's twelve-step colour wheel, the first of its kind developed in 1666. Colour wheels like this one function as visual representations of colours arranged according to their relative chromatic relationships. The structure of the wheel positions primary hues at equal distances from one another, and then creates chromatic progressions between the primary colours by using the secondary and tertiary colours.

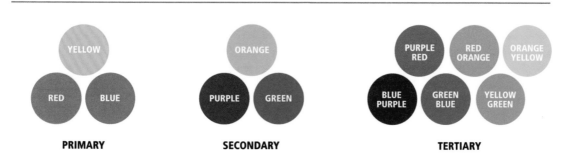

Primary Colours: These are colours at their most basic, those colours that cannot be created by mixing any others.
Secondary Colours: Those colours achieved by a mixture of two primary colours.
Tertiary Colours: Those colours achieved by a mixture of both primary and secondary colours.

THE PROPERTIES OF COLOUR

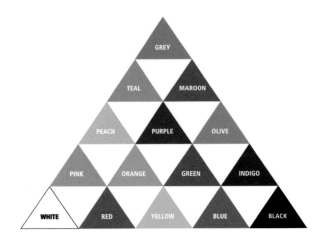

COLOUR TRIANGLE

The diagram to the left is structured much like an extended version of Goethe's Colour Triangle, but functions according to quite different principles. Namely, any two colours from the baseline can be traced diagonally upwards to the colour they make when combined. For example, *Yellow* and *Blue* make *Green*. The innermost three-part triangle forms the secondary colours of *Orange*, *Green*, *Purple* whilst the central three colours on the baseline are the Primary Colours.

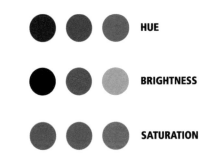

HUE, BRIGHTNESS, SATURATION

The diagram to the left shows the three key means to describe colour. *Hue* indicates the shade of blue dependent on the relative colour mixing involved, and its position within the colour spectrum. *Brightness* signifies the relative amount of black in a colour, with more black creating a darker colour. *Saturation* refers to the intensity, richness, purity and strength of a given colour, like red.

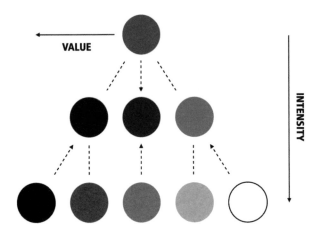

COLOUR VALUE & INTENSITY

The diagram to the left shows how the Saturation and Value of colour can be manipulated through the addition and subtraction of white and shades of black. By adding black to the blue colour it not only becomes darker but the Saturation also changes, causing the original blue to become more neutral. Similarly when white is added the intensity of the blue is dimished and it becomes not only lighter but also more neutral. However, when grey is added to the blue the saturation is diminished but the colour value remains the same.

SPECIFICATION & REPRODUCTION

Pantone

This is the brand name for the international and design industry standard system for colour identification and communication that utilises a series of reference guides. This system is used by designers, suppliers, printers and clients to choose, match, specify and manage colour in any application, anywhere in the world.

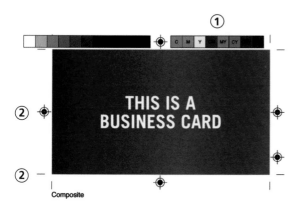

Composite

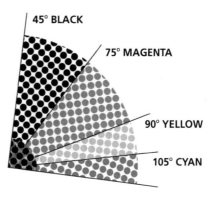

45° BLACK
75° MAGENTA
90° YELLOW
105° CYAN

1. COLOUR BAR

This device is used by the printer to colour match, and appears on proofs and printed sheets outside the trim area (the area outside of the small lines seen in the image above).

2. REGISTRATION MARKS

These small marks firstly allow the printer to exactly match each of the four colour plates correctly, and secondly to cut the final printed object to the correct size.

SCREEN ANGLES

Offset lithographic printing uses a four-colour process to create all the colours present in the original image file or design artwork. As each colour, or plate, is printed in tiny dots at different angles, the human eye visually combines these four colours to produce all the others. These dots can clearly be seen in the image above to the right, which is a close-up of a newspaper. Each colour plate is called a Colour Separation, whereby a full-colour image is separated into each of the four-colour values (CMYK), namely – Cyan, Magenta, Yellow and Black (Key).

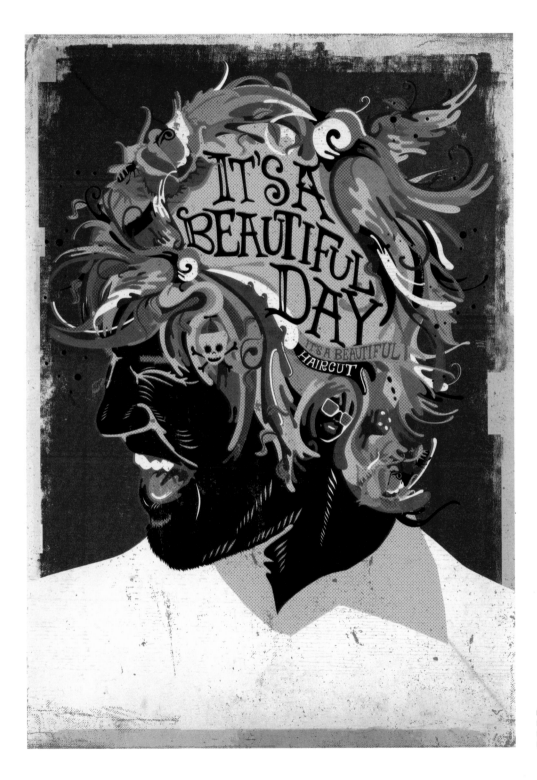

Left:
Poster designed for the Floyd
Barber Shop for Cross Colours
by am i collective

Colour is one of the designer's most powerful tools. There are many ways colour helps communicate a message – colour can communicate specific meanings, express a personality, differentiate, frame, add emphasis and highlight content. Visually appealing designs usually make use of consistent colour schemes, meaning a consistent system of matching hues. Without colour, a page can lack personality and look dull. Alternatively, the wrong colour might communicate the wrong message entirely. The tone and hue of the colours you use might also make an otherwise contemporary design look dated or old-fashioned. With a considered, appropriate and balanced colour scheme, a design will have a consistent and balanced personality to match. Too much colour, or the wrong colour, gives a page a confused personality and makes it too busy, causing the reader to ignore it and move on.

Clockwise from top left:
Invitations to the annual Nadine Gordimer Lecture at WITS University by Flow Design; *Afro Magazine* 2 by Peet Pienaar and Heidi Chisholm; illustration for a story on racial tension, *Campus Times* (*Mail & Guardian*) by Jason Bronkhorst, Infiltrate Media; I Heart Durban by Scott Robertson, The Curators

9

Opposite:
Exhibition design by Carina Comrie

9 Q&A with Industry Practitioners

Peet Pienaar, *The President*

Ruan Vermeulen & Mark van Niekerk, *am i collective*

Olivier Schildt, *Rex*

Carina Comrie, *Bon-Bon*

Richard Hart, *disturbance*

Garth Walker, *Orange Juice Design*

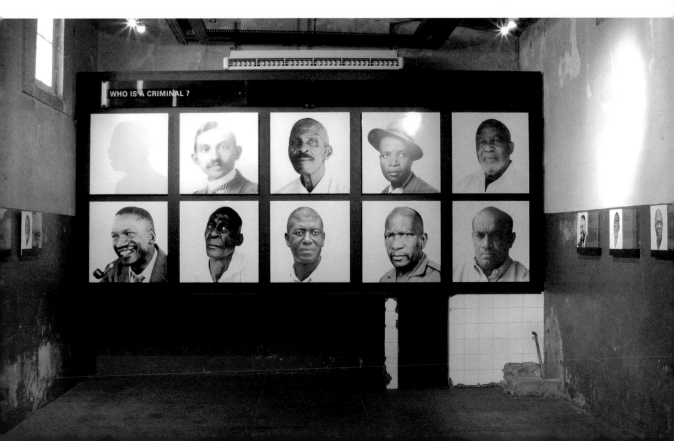

An interview with Peet Pienaar
Creative Director – The President, Cape Town

Promotional poster for the play *Altyd Jonker*

www.thepresident.co.za

Biography

Cape Town-based Peet Pienaar was born in 1971 and studied Fine Art at Stellenbosch University. This was followed by several years as a performance artist before he consciously changed careers to become a graphic designer, principally to reach a wider audience. This he has achieved very successfully – previously as the Creative Director of daddy buy me a pony and, more recently, through a new design venture called The President. Pienaar is also responsible for the widely acclaimed *Afro Magazine*. He is passionate about the environment he lives in and actively draws from the South African and African contexts in his work.

Q. With your core focus on design for print, your work evidences a substantive degree of specialisation coupled with the covergence of social intent and a developed idiosyncratic aesthetic. Would you encourage young designers to specialise or diversify?

I think definitely specialise. When designers come in and say they can do websites as well as this, this, this … it is the way that you think about print. To really get to the level of doing something interesting, you really have to go into that medium. And with print and digital being so vastly different I don't think that you can be really good at both. So I would say people should specialise [and]… decide to go either into digital design or print design. And decide if you want to do commercial work or design that is more oriented towards the arts, because these are two different ways of thinking.

Inside spread from *The Outlook Magazine* in Hong Kong

Q. Do you have a design philosophy? That said, do you feel design philosophies have any currency?

It's very difficult to say I have a design philosophy. I think every person would say either this is good design, or this is bad design but to put it down to 'my design philosophy', I don't know. It changes all the time.

Q. Do you think even the idea of a design philosophy is of any value?

I think design – and maybe this is the philosophy – comes so much closer to art these days, and therefore… defies what design is. I don't think one can really define it, so to put a philosophy behind it… Maybe that's the philosophy: that it's not really a philosophy.

Q. What role do humour and irony play in your work?

[There is] not a lot of irony, actually, but humour is very important to me. It is very, very important in design. There is nothing worse than serious design. When people interact with your work they need first to want it

– to keep it – and then it must make them feel good about having it. It might offend them a bit... but I think that the whole desire thing is really important. I mean it's not humour like 'ha ha', but it is important. I look at something halfway [through the design] and say this is getting very serious and we have to do something now about getting some fun elements into it, or lightening it completely. Even if you work with big corporates... people need to be entertained by being exposed to your design.

Q. Do you see visual languages indigenous to African countries as an overt vernacular to be actively explored, developed and integrated into your creative output from an aesthetic perspective? Or are you more interested in promoting local semiotics as a strategic and social endeavour in the face of a growing global monoculture?

Well it's two things. Designers in South Africa are second-hand versions of what's happening in the West design-wise. If you want to copy, or be inspired by design in Europe... context is so important for that stuff to actually come to life. If you look at Dutch design, it's very important that it's in Holland and not here, because it just doesn't work here. People are so influenced by what's happening there [that] they do it here so that it is like bad versions of what's happening there. So for me it's important to look at what is happening in Africa and create a contemporary cool language that people feel is from here but is still funky and cool enough to aspire to, rather than copying something from wherever [that] just doesn't work because it is out of context. ...for me it was more [important] to look at what is happening outside of South Africa – like for instance in West Africa, or Nigeria, or the DRC in terms of design – and to create my own visual look, or work, than to look at what is happening in South Africa, because here it is a mash of bad UK design and superficial American influence. So to find something that I could start working with it was important for me to look to the DRC and West Africa mostly.

Q. Is that because it's more, in a sense, primary, it's less interrupted?

No, I wouldn't say primary. I think it's less interrupted. And there is not a lot of money thrown at stuff and therefore you have designers still playing a big role in society since it's not as commercial as here. I also think the fact that a lot of stuff is done by hand... I don't know if it is primary because there is a very strong sense of design, maybe a much stronger sense of design than here. Things are quite symmetrical... maybe it's intuitive, but I don't think so. There is definitely a much stronger sense of design there than here.

Q. Is that a legacy of a visual culture?

I think so. There you'll be a painter or a sign writer, but your Dad would have been one too. So it comes with family. It's a really long tradition or history of design coming through... it is taught from generation to generation, where here we don't have that at all, we do not have a history of design.

Q. Why do you think that is absent here?

I think it is the way our society is constructed. Look at how, after apartheid, all the logos and stuff were suddenly changed, and now we don't know any of those designers in South Africa. We don't know who designed the

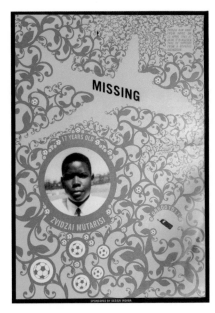

Poster for missing children

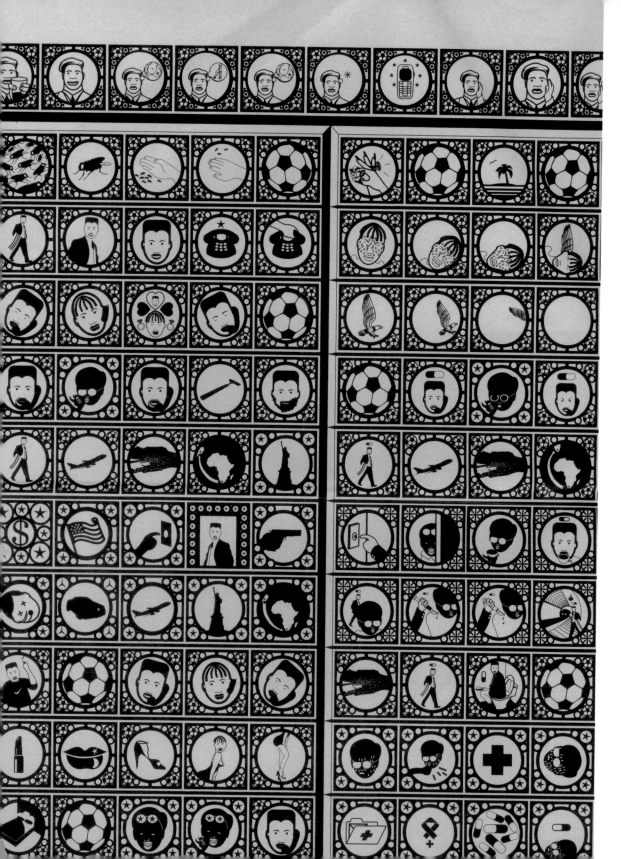

post office logo, the SABC logo, all those logos, who designed them? We don't know. Everything was just chucked out. There was a design history and it was linked with apartheid, but we never looked at it as a design history. Maybe it was influenced by German designers who came here with the printers... it did have a strange apartheid feel that was also linked to a German kind of design. But how would we know... now it's too late to know who those old designers were. In Europe, design history is so important. If you use a font, you are making a comment. It's so so strong. Here, Futura doesn't mean anything. There if you use Futura it brings a whole context to your design. I think in West Africa there is much more of a sensibility of why you use a certain design, why you use certain names and colours when you design things.

Q. Briefly describe the processes behind the *Afro Magazine* project.

We saw *Afro* and the other stuff as research [to discover] what is Africanism? What are the principles? Not necessarily exactly what does it look like etc, but more what's the humour that people use? [What are] the values in design, and when people use typography what kinds of fonts are they using? Why are they using those fonts? Ok, people were using PCs and these were the only kinds of fonts available on PCs. So then we say... let's look at those kinds of fonts and say those are the kinds of fonts that we'll use. Then we look at leading, what kind of leading are people using when they do it by hand. [We were] really analysing it... what kind of humour is it? What's going on? What happens when they use American symbolism, like a Nike logo... why do they use it, what is the thinking behind it? Then we can use another logo because we are applying the whole thinking behind it. So that's the kind of stuff we try to work with.

Q. While *Afro Magazine* clearly evidences a highly developed, delirious idiosyncratic visual language, would you describe the social objectives of the project? That said, do you see *Afro Magazine* as a form of dissent?

For me it was very important to bring out something that people here could look at, [so] that young people could think, wow, Africa is actually quite interesting. It isn't boring, it is quite something. In Europe and in the East it has been incredibly successful in that sense. Suddenly people sat up and said hey, there is some design that is happening in Africa and that is interesting. So without thinking beforehand, this is my aim... I was just bored with what was happening in the West and I just really wanted to know. The only way I'm going to learn anything is by doing a magazine... because that's the only way you really learn anything about it. And that's how it started. I just wanted to know more. Who are the artists? Who are the musicians? Who are the writers? What's going on?... I wanted to give a face to what is happening in Africa to the rest of the world. We are all used to speaking about Rwanda and how many people [have] died [in Africa], for instance. But [nobody says] oh, Fela Kuti was one of them. And it makes much more sense if more information about Africa were actually coming out, because we would then understand it more... but now it's just figures... we don't know what is going on and we don't know who 'these people' are.

Cover design for *The Outlook Magazine*, Hong Kong

Once-off cover and full editorial design for the spring 2007 issue of *VISI* magazine, South Africa

Opposite:
Detail from a poster design titled *Story Without Words* – South Africa has eleven official languages, and the idea with this piece was to communicate a visual story that could be understood by everyone

Q. In terms of not only physically looking at things, but the mechanics of looking, one of the things Garth Walker was talking about is that the reason he's focused on South Africa is because it's a vernacular. South African aesthetics are a vernacular, in particular those in Durban. He can only really see in this context. When he is in London, he can't really see, it's like this glaze comes down.

Yes, totally. If I go to Zurich, I feel as though I'm on a film set. There is no engagement for me. It's just completely impossible, I can't engage with it at all... and it's not anything to do with first or third worlds, because I just went to Rio and I couldn't engage with it [even though] the situation is very much the same as here. But there was just nothing I could engage with. I didn't feel the same. I couldn't look at the stuff the same, [not] like when I go to the DRC. It was just not there at all. I think it's where you feel at home. You're at ease, you feel more comfortable. I don't have the basis to start understanding what I'm looking at when I'm there. It's like the carpet is out from under me. There is lots to look at but I don't know... what am I looking at. But... after *Afro*, the way I look at things has changed. I'm not that focused on examining what's happening in Africa anymore. At the moment I think I'm much more focused on developing my own thing. I think I had that craving to indulge in my context and in Africa, to have this link between me and Africa, but now I feel much more... to focus on what I am doing... and not so much on being influenced or categorised as African. I don't know why that is, I can't really explain it.

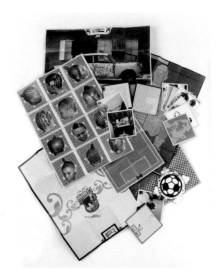

Q. The idea that design inspiration is largely conditional to various local temporal and contextual specifics like history, socioeconomic structures, access to technology, the vernacular, language and culture is largely a given, and has proven currency. However, aside from being able to communicate a political message – how effective do think design is at exercising social influence, exerting a political will or affecting change?

I don't think it is working a lot at the moment. But I think it can be very influential and inspirational. One of the reasons why I got out of the art world was because I felt that it was too incestuous and too self–satisfactory, and design was for me a little better in that you are actually doing this third thing: communicating, or doing something that has real influence. Also the type of audience was for me more interesting. But, for instance the shoes I'm doing now, the sneakers, were entered as an artwork but were more of a design thing. It's a sneaker that we are working on with Jordan Shoes. They used to make all the Nike, Puma and Adidas products for the South African market here before it was all moved to China. So they have a factory here, and all the workers, but they don't have enough work for them to do. So they've had to close down the factory slowly, slowly. I was working with a girl from Camper doing a design job for them and... we realised that the problem is that we don't compete with design. And if we could compete for design with Nike and Puma... then there is no reason why we can't bring out our own brands in South Africa that could keep the factories open and sustain them completely. So we started designing a sneaker that... will probably go into production in the next month or so. For each sneaker we sell, because we make them locally, we can get the factory to make two pairs of school shoes. If we make one pair of sneakers, the factory will actually make three pairs of shoes. So the factory will have three times more work and the kids who don't have school shoes will get them for free... I think there are ways

Afro Magazine 1, a magazine dedicated to contemporary culture in Africa, designed and published by Peet Pienaar and Heidi Chisholm

one can actually make real change if you work at it. But it is important to go the whole way and get it into stores, into the market... so it's a real thing, it can't just be an artwork, an idea. It has to be real or otherwise it won't work. And that for me is the difference between art and design... art is a lot about ideas. In fact most of the time it is only about ideas. There's this practical side of design that allows you to be real in a way which is really great, that allows you to have real influence.

Q. For several years South African artists have been active, engaged and productive at an international level. The rise of several new, young artists to the international arena more recently sees that trend set to continue. Whilst the local art world has grown exponentially in the past several years, with a large number of art galleries emerging at a national level featuring the work of confident, locally-centric, critically engaged and commercially viable young local artists. Events like the Joburg Art Fair see this trend continuing. Despite the establishment of successful events like the annual Design Indaba conference, as well as institutions like Think (Design Council of S.A.) and coupled with the legacy of the Loerie Awards – the graphic design sector does not appear to be on a similar trajectory. Is it a case of rapid catch-up on the part of the visual art sector or is the design industry simply not moving at the same pace? What reasons or factors (commercial or socio-economic) do you attribute this to? Do you think government is lacking in this regard? Or is it something absent within the industry itself?

I have huge problems with Design Indaba. It is an example of something that really really didn't work. Because after ten years of Design Indaba I don't think there is any growth, and to just pump designers and to just talk about their work here is not going to help anyone. What we're going to do, from August, is bring in the first designer – it's not a workshop, it's more like a course. We're bringing in a designer who is going to give a typography course, a hardcore course. And then you do it, you learn from it or you chuck it out. So we're going to be bringing in designers to see if we can't get into more serious technical stuff, and maybe that will help. The other thing is that people at Design Indaba are pushing international design. It's making people confused. There is no such thing as international design. It doesn't exist. You have a very strong Swiss design, you have a very strong Norwegian design, you have American design, you have a very strong British design, and to say this is international design and we have to do something in between is just... [false]... I did a workshop in design in Macedonia in Eastern Europe with designers from Switzerland, designers from Norm who were designing the new Swiss money. In Eastern Europe there were twenty-five designers from all the Balkan countries, all the best designers from all those places and they sit with all the same problems as we do. Europe is so strong in terms of design and they just want to be like that. They just can't... it's no wonder people don't take it seriously.

Q. How do you approach the day-to-day business aspect of running a design studio? How do you generate new business? What do you look for in clients?

Interestingly enough, a lot of our clients came after we did *Afro Magazine*. People come to us because of that, which is interesting because they want work like that, not because they want you to do stuff that they want. They

Afro Magazine 2, a magazine dedicated to contemporary culture in Africa, designed and published by Peet Pienaar and Heidi Chisholm

are buying into the look and the whole way of designing. So we get a lot of people who come to us and say we really like *Afro*, can you do a corporate identity for us. They don't necessarily want it to look like that, but they just like that kind of work. For me the most important thing is to do what you do, and do what you want to do and then people ask you to do more. Rather than to do what people want you to do, and then ask you to do more of that. That to me is really the approach. If you are going to start doing [poor work] for people, the clients are going to ask you to do more [poor work], and then that's all you do. And if you just do cool stuff, then people will just ask you to do cool stuff and that's what you'll do. That's the only way you can do cool stuff. Because you can't expect suddenly for people to change... because you've been doing [poor work] and then suddenly you want to do this cool thing.

Q. Do you feel self-initiated or personal projects blur the distinction between visual art and design or is it simply a case of playing dual roles of designer and client?

For me personal work or your own projects are very important, because if you're churning out work for clients all the time you don't get time to think about what you're doing. In terms of new visual languages, little things do develop typography of your own again... like little tool boxes you've built to use on clients' work. And that is how I see personal projects... It's really like developing things... and then when you start doing clients' work it goes quickly because you have a whole glossary you can use and stuff that you have already solved [by] thinking through in other things. So that for me is the way we've worked with our own work and... why it is important to do your own stuff also. When you see a client's work it is a bit blurred because it looks like your work anyway.

Q. What influences your decision-making when interviewing and hiring creative staff? What are you looking for and what differentiates one young designer from another?

That's a difficult one. I don't know, because I look at all these design studios with their portfolios and they are all the same. So I ask what else they have done? What else are you doing? I just want to see what they think and if [they] are really passionate about design. That's actually what I want. I want someone who is really passionate about design. Because then if someone is really passionate about design and loves it then you can work with them. But if they're not, I don't care what skills they have, if they just want to have a salary then it's not going to work.

Q. Does personality play a role? Do you have to get on with the person?

Not really, because if you're passionate about design then it's inevitable that you're going to get on. Especially in such a niche sector as design. I mean how many people are passionate about design in this country?

Q. Without viewing their portfolio, or knowing anything about them, what advice would give to a young South African designer beginning their career?

I think they must think they can actually change design in this country. They must not be afraid to do it. They must be so passionate about it, and believe

A1 invitation and poster designed by Peet Pienaar for a design exhibition for *Afro Magazine*

Poster for Cape Africa Platform

it. They must say everything else is bad but they're going to do this. Say 'I'm so sick and tired of all these [bad] magazines around, I'm going to show you how I can to do it better', and then start doing stuff. That's the only way you can do anything. I think it is easy to effect change in design in this country. It's really easy. It's an easy field. I think it's undeveloped, it's not looked after, there are a lot of people in it, although not a lot of people are doing interesting things. It's easy to impress, it's easy to please. Just the level of design at the moment is so [poor]...

Q. Briefly describe your education background.

I studied fine art and not design, which I think was a good thing because it taught more about design than designers are taught in terms of composition and colour basis and all that kind of stuff. I don't think design schools are adequate to prepare students here. I think art schools could be, if they structure themselves, and bring in a commercial component to art schools, like business. I think that would be great. Then I would say, go study fine art with a business module. A real business, a proper business MBA kind of thing... learn about marketing, what are markets, that kind of stuff. I haven't done that, but of course it's useful – you can't be a designer if you don't know that kind of stuff. And you don't learn that at design schools. I mean you can teach yourself a programme... I think if you do any design you need to know who it is for, how many people it is going to reach, what does it have to communicate to these people? Basic marketing stuff. Art is the same. Even if your market is art lovers, it's just the same.

Q. What is the best thing about being a graphic designer?

Artists don't know where to place you!

Poster/page from *Afro Magazine* 2

An interview with Ruan Vermeulen & Mark van Niekerk
am i collective, Cape Town

www.amicollective.com

Biography

Catering primarily to advertising agencies, am i collective is a young Cape Town-based creative studio of variously skilled individuals each bringing to the table their own unique ability – be it in design, illustration or fine art. The collective also indulges in projects of its own on an ad hoc basis, as inspiration dictates.

Q. Briefly describe who am i collective is, and how it started.

RV: I think on a social level, and also aesthetically, we definitely relate to what Bitterkomix is about, what they are saying. Also with the guys from Fokofpolisiekar... we loved the stuff that Fokof started. They were the movement that changed the South African Afrikaans rock scene forever. Nothing will ever be the same. We were inspired with what they were busy with two or three years ago, also with being in Stellenbosch and knowing that these guys were also sort of from Stellenbosch, and being inside that student culture – with the guy that used to do the design for Fokof, Matt Edwards. He did some radical stuff. We did not feel threatened by him but we also wanted to be making work like that. But he was designing for an alternative Afrikaans rock band. So we thought why don't we start an illustration company, like a collective that acts as a rock band?

Q. So taking that methodology...

RV: Yes, taking the methodology, balls to the wall rock 'n roll, lets just do what we want. And funnily enough the year when we started, in this house... there were three rooms. Christo, Rudi and I stayed in the house... and then Chris and myself had the two rooms, two bathrooms and the living space and kitchen so all we did was just work and sleep. That's it.

Q. So did each of you have your own client base?

RV: What we did was we got Mark [van Niekerk] involved. Mark used to have an advertising agency called Lunch, which he sold to King James. I used to work for Mark in Stellenbosch. And basically what happened was I didn't dig what I was doing. I didn't like doing marketing and all that [stuff]. And he was a bit sick and tired of that whole corporate work. So I told him, listen man we are starting this thing. We started doing work for Metropolitan and we realised that there is good potential here if they... jump on this. So we took a chance and said listen if they jump off the bandwagon we can really start something. But we can't manage it properly because we're creatives. We don't know how to quote. We don't know about tax and all that stuff. But that's totally [Mark's] business. So he said, fine. He's leaving his company and we have six months to see if we can make this work. And eventually it did and this is where we are.

Q. Designers generally specialise – whilst your core focus is illustration, your work covers a wide range of cross-media. Would you encourage young designers to specialise or diversify their skills?

RV: Yes, what usually happens is that we don't want to stand for a specific style... one thing that we particularly do a lot of is specifically hand typography. We have been labelled as an 'African style', but then again we have also been doing a lot of international work.

Opposite: **Page design by am i collective**

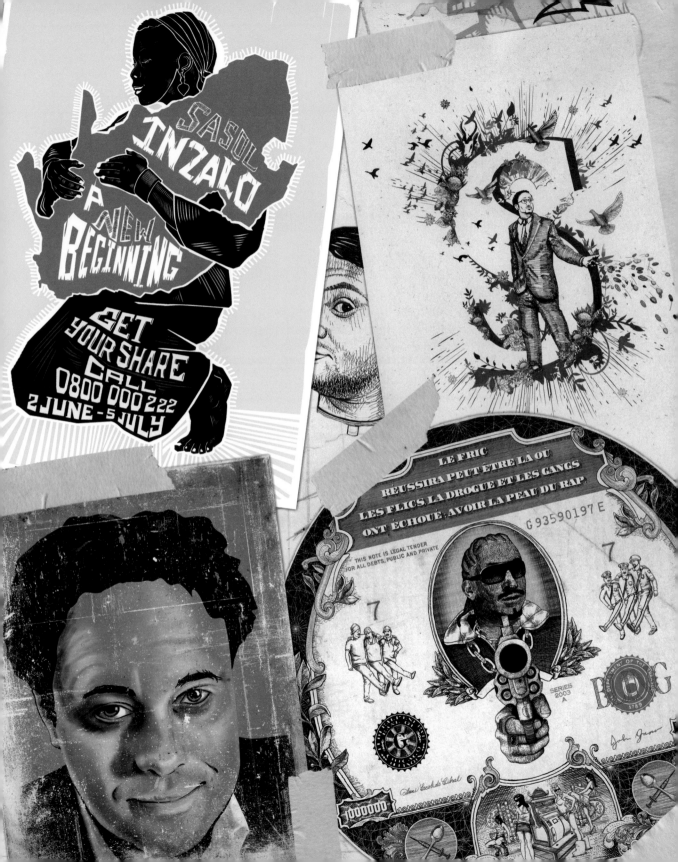

MVN: To be commercially viable as a business, over the past decade it has been arts, and then photography is the next in thing. So, it's a cyclic thing... we are very aware of that. I don't think illustration is as happening overseas as it was four years ago, but we are getting the spin-offs of that. So we are riding quite a crest here in this country on illustration. But to become commercially feasible you have to diversify. I think the market is quite tight and small. I mean if you look at what we have done in two years, that is how small it is. It is so small, so if you do something and you do a good job, then everyone is going to know about it and hopefully latch on. I really think we've reached the platform in terms of exposure. And then you're obviously going to say well illustration is also now at its max. We want to become more known as a studio with talented people, offering creative solutions to whatever challenges the advertising industry has. That's what it's about, it's not simply about the supply of illustration. Illustration per se is a great space to be in, and we started as illustrators. As a company when we started the guys were doing websites, you name it, to earn a living. We positioned ourselves as specialising in illustration. But this evolved and changed as the clients asked us to do different things – we are obviously satisfying a need out there.

Q. What role does the computer play in the production of your illustration work?

RV: The big thing is that we try to do most of the stuff by hand. What happened is that we ended up buying tablets and started doing the hand thing on the computer, purely because of the time issue. But I must say, most of the ideas start from a scamp. Most of the stuff we do ends up being done through pencil, then that is scanned in and then inked up with tablets. So there is always a lot more of a hands-on approach to all the work we do, where the computer usually plays a big role from a time perspective, as well as technique and using the applications that are there. Not necessarily taking applications like Illustrator or Freehand, for example. Freehand is a very good example of this, not that anyone uses it anymore. Freehand is more of a design tool – you use [it] to design, not necessarily to illustrate. We ended up doing illustrations using Freehand where you can't actually see that it's been done in Freehand. So you are utilising the tools in a different way to the way they are meant to be working. For instance, in Photoshop we are doing almost matt painting with photorealistic stuff, which is great – that is the purpose of Photoshop. But it still has an illustration feel to it. It still feels as if it is generated by hand because you are actually doing it physically by hand.

Q. What advice (creative, life or business) would you give to a young designer or design student starting out?

RV: We have a programme where we try to get interns... What usually happens [is that young designers] go to the agency and end up scanning stuff for three months. You do not learn anything. What we try to do is get those young, raw creatives in here and tap into that.

MVN: I have one very simple word of advice and that is you cannot attach enough value to humility. No matter how good you are, or how talented you are, that talent is something you are born with, you are a lot luckier than everyone else. And if you can keep that in perspective... and be humble as a creative... I have seen too many hot creatives mess up completely because their egos just get to them.

Q. So the person should be a sound human being on top of being talented?

MVN: Exactly, because everyone says that to have this talent is a special thing. A guy can run 100 metres in ten seconds without steroids – he has been given that. It is no reason to be self-satisfied... I think creative people lose [sight] of that: that it is a talent you have been given and you need to be open to comments coming from your peers and colleagues. That is my biggest word of advice. You are never better than the guy next to you. We have guys here who are extremely talented, and guys who work damn hard, who do not have the same talent and sometimes are battling. But again it goes back to our ethos about humility. A guy walks in here without humility, and he is not going to belong in this particular business set up.

Opposite: **Page design by am i collective**

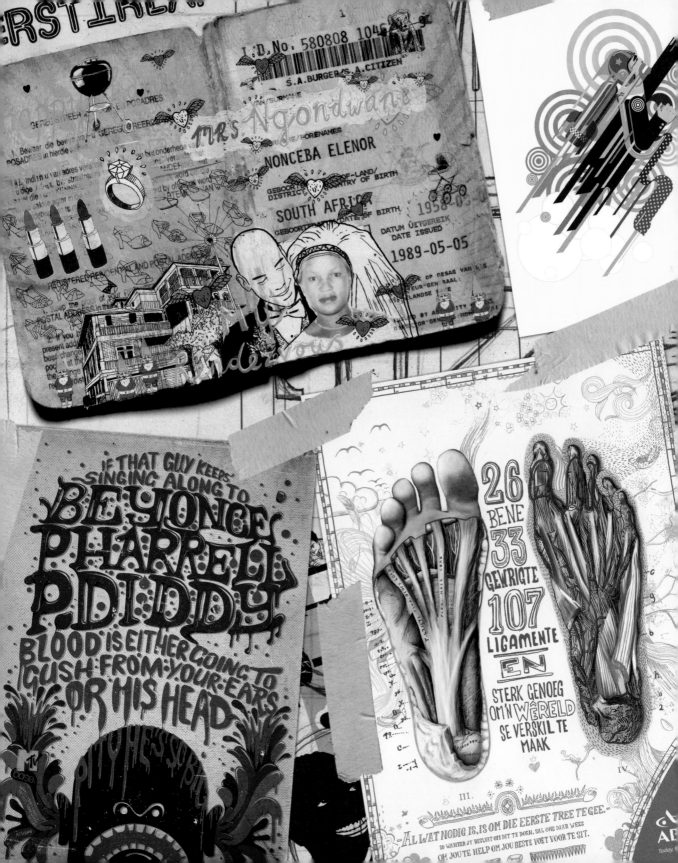

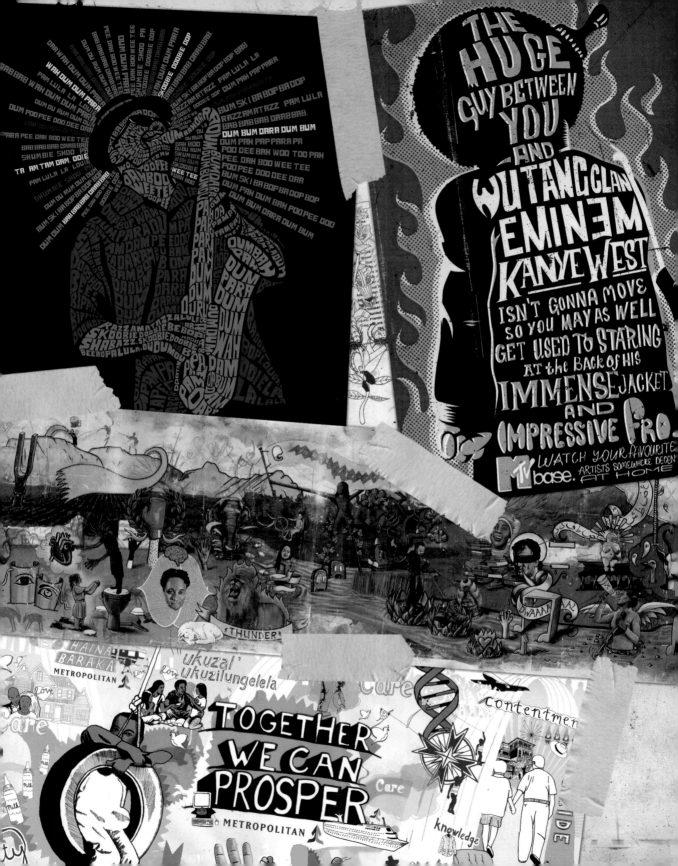

Q. What role do humour and/or irony play in your work?

MVN: Humour is key. I think if you are not enjoying working in this environment it is going to affect the kind of work you produce. This is where we have an edge on some of the agencies. I am not slating agencies; they perform within a very specific structure. We don't want to interface with clients, whereas agencies, that's their bread and butter, and with that come a lot of parameters. Agencies do that, and there is a lot of fun being had out there. We are pretty relaxed about our workspace. Everyone is committed to what they are doing here.

Q. How do you approach the day-to-day business aspect of running the collective? How do you generate new business? And what do you look for in a client?

MVN: ...again, we go back to structure being an enemy. We want to keep it as random as possible. So the people here... respond to briefs and not to time structures. Obviously there are deadlines, but if the guys are not busy, they do not have to come to work. So it is a very loose structure. In terms of the day-to-day running of the business, we are trying to create an environment that assists creativity as much as possible... We are small enough, we do not want to be bigger. We are fifteen people, and will keep freshness through the one-year internship programme. I think keep it relaxed day-to-day. A couple of things – quality is not negotiable, and we do not miss deadlines.

Q. What does the future hold for both South Africa's creative industries and its youth culture?

RV: I think now is a very cool and exciting time because there are a lot of small and exciting little galleries opening up. There are many small little hybrid creative things happening now. People do not want to go and work for the big dudes anymore. They want to work for small little collectives. And maybe it stays alive for two, three years and then dies down, but that is cool. Through the process you learn, and you get to know other people and that is cool. So I think being a young creative in this country now is an exciting time. Really.

MVN: In terms of the South African creative industry, and the influence this is having throughout Africa mostly via South African-based companies operating throughout the continent: they are not finding creative collectives in Rwanda, for example, at the moment. So for South African creative talent there is an opportunity to influence creativity throughout Africa, and even globally. I think... Africa, but South Africa in particular, is becoming increasingly discovered as new, as a breath of fresh air into creativity. The first world is slowly latching onto an African... a contemporary African influence. And it's not your typical Nguni, Sotho patterns. Or a giraffe. So I think there is huge opportunity.

Q. Do you get the feeling of there being a healthy, robust creative design sector in South Africa with an educated client base or is it rather a cut-throat industry characterised by under-cutting and fly-by-night charlatans coupled with uneducated and uninterested clients focused on the bottom-line?

MVN: I think there is a good design ethic in the country. From a design perspective. There must be a healthy spirit of design in this country. I think it is healthy. [But] we need to get over our complex about being a third-world country. Our design is brilliant. I don't think we have to stand back for anyone.

RV: There are also uninterested clients focussed on the bottom line, on getting the message across, on getting the logo as big as possible because supposedly that's what needs to happen... it is very seldom that you find a design-educated client.

MVN: It is growing though, especially where we are using the international agencies. The South African clients are a lot more... they pull the reins in a lot more. It is unbelievable what guys are doing overseas. When we send work overseas we think they will never approve, and it then gets approved. It is because we are so used to clients here. But in South Africa the educated client base is definitely growing more and more.

Opposite: **Page design by am i collective**

Q. What is the best thing about being a graphic designer?

RV: Well you never know what is going to happen today. That's the cool thing. Also you are always doing something new. The coolest thing also is that there are really no boundaries. There are no specifics.

MVN: Everyday is an adventure. If you compare it to other professions... take a GP: he's only going to get really excited if someone comes in with a really strange disease. There's no routine. And it is an adventure. You are responding to new things everyday. You are thinking about new things everyday.

Q. So there are no rules?

RV: There are no rules. If you are trying to accomplish something there are no rules. That type of thing. I think the client outline, the agency, they've got rules obviously. But for us it's 'why can't you do this?' There is no reason you can't do this. Let's do it, let's open up a gallery, and let's put the dogs up, what's going to stop us? ...when we started this thing I said to Mark, listen I want to do this. I don't know what we're doing but we want to do this. It's that mentality: not knowing what is going to happen specifically drives creative people.

MVN: The challenging aspects about working as a creative are definitely egos, deadlines and clients.

Opposite: Page design by am i collective

Opposite:
Page design by am i collective

Left:
Work created for a climate
change exhibition arranged
by Pocko in London

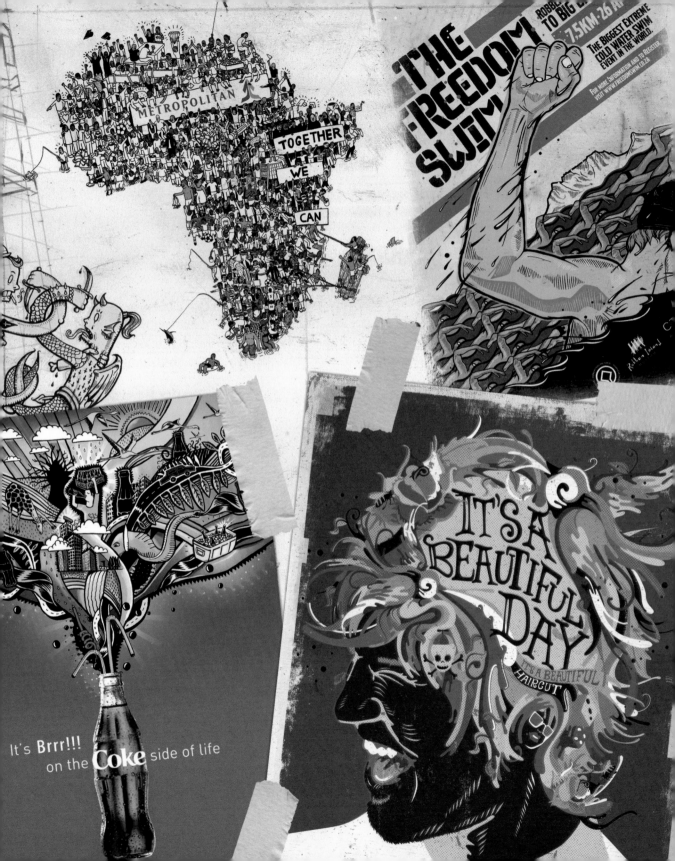

www.rexworldwide.com

Biography

Olivier graduated from the University of Pretoria with a degree in Visual Arts and Information design. After working for a progressive new media company, Delapse, Olivier departed for the US and Europe in 2001. During this period, he was contracting as a freelance creative director in New York, London, Berlin, Brussels and Paris. 2003 saw Olivier return to South Africa to launch November Communications, focussing on the development of innovative projects with creative visionaries. This undertaking saw Olivier surrounded by an immensely talented network of collaborators from all over the world – Michaël van Straaten, Marc Kremers and Quatermass Records to name a few. In July 2004, Olivier joined forces with long-time creative comrade, Rudo Botha, to birth REX Creative. Their complimentary skills and shared passion have seen REX grow into a creative consultancy respected for the iconic branding interventions they are able to deliver. His portfolio includes clients such as BMW, Coca-Cola, Paramount Pictures, MTN, The Constitutional Court of South Africa, CellC, and The Nelson Mandela Foundation.

Q. Producing work for print, digital media, product design and environmental design, Rex covers a lot of ground. Would you encourage young designers to specialise or diversify?

Both. The thing is this... being creative is a mindset. I'm of the opinion that somebody who is inherently creative can dream up the interior of an airport one day and then design a monogram for their local butcher the day after. What makes you able to pull of both very successfully is craftsmanship and execution and this is a learned skill that takes time. So, if you have time and are in no rush with your career, then diversification is a rewarding path. Inherently you will also become quite specialised in more than one discipline.

Q. Do you have a design philosophy? That said, do you feel design philosophies have any currency?

I guess we do. We are not defined by the medium we work in. Rather we are defined by our ability to solve problems, beautifully. As for having any currency, as long as we have conviction for what we do, we keep on doing it...

Q. Why did you become a graphic designer? Not how, but why?

I wanted to become an artist. You know, the struggling type like Picasso in his youth. I found that to be a noble lifestyle. But I also wanted money so I could travel, be financially independent, afford a good meal and so on... So I settled for graphic design.

Opposite:
Coca-Cola's M5 Campaign – a global brand intervention aimed at the trend setters from generation X & Y. The campaign involved brand strategy, packaging, animation, merchandising, promotion, illustration and graphic design in collaboration with Tennant McKay.

Tennant McKay™

WWW.REXJHB.COM
WWW.TENNANTMCKAY.COM
JOHANNESBURG
SOUTH AFRICA

M5 AFRICA
WWW.ICOKE.COM/M5
WWW.THEM5.COM

Q. An increasing component of your business is generated and implemented outside of this country. How do you relate to the notion of international design? Does such a thing exist? Can design exist within the brief but outside of any specific context?

There is no doubt that the world is shrinking faster than ever and looks like it will keep doing this for some time to come. Inside this shrinking world we find indeed an internationalisation of design and it is ballooning as fast as the world is shrinking. Like it or not, for good or bad reasons, it's fact... this is where we live. It has been my experience that if you work with global values such as integrity, attraction and respect you create work that billions of people will understand.

Q. That said, do you think South African design travels well?

Anything travels well if it has something valuable to say. It's all about the story, not the 'look' of the design. Design is rather the vessel for the story.

Q. You live and work in Johannesburg – firstly, what do you gain from this context that cannot be found elsewhere? Secondly, what are the challenges of working within this context?

I do love Johannesburg. It is infinitely diverse. I have lived and worked in many European capitals, and nowhere have I been as impressed by my surroundings as here in Johannesburg.

Q. Design in general is currently being fêted as the new art; graphically driven street art as a viable alternative to gallery-based hegemony and industrial design as a desirable commodity. Do you think this is a healthy trend, or should graphic design especially be wary of this kind of attention?

Justifying art, or design for that matter, has always perplexed me. I'm all for the craft to be hidden or packaged for some wealthy collector... who am I to pass judgement on someone else's desire to elevate something that yesterday was a sweet wrapper?

Q. What role do humour and irony play in your work?

Little humour or irony. It's not what makes me tick.

Q. Do feel there is a healthy, robust design sector in South Africa with an educated client base or is it rather a cut-throat industry characterised by under-cutting and fly-by-night charlatans coupled with uneducated and uninterested clients focused on the bottomline?

We certainly have very talented designers who, over the years, have become equally talented persuading generally conservative clients to create work that is truly compelling. But, these works still remain few and far apart. The general client is still very conservative in South Africa and comfortable going with something that they have seen before – they just don't know how to make a decision that is unexpected and thus they miss out on so many opportunities to create great new work. There

Corporate brand advertising campaign for South African law firm, Webber Wentzel Bowens

Brand identity, catalogue and internet presence for Willowlamp

Opposite:
'History Lesson' – promotional campaign for Look & Listen, in collaboration with Mick & Nick

On the 1st of January 1977, The Clash played opening night at The Roxy Club in London, punk's first real venue. On the 2nd of January 1926, the first issue of Melody Maker, the publication for 'all who are interested in the production of popular music' went on sale in the UK, it cost 3 pence. On the 3rd of January 1973, The Beatles recorded their last song together, it was called 'I Me Mine'. On the 4th of January 1986, Phil Lynott of Thin Lizzy died of heart failure. On the 5th of January 1969, Marilyn Manson was born. On the 6th of January 1979, The Village People have their only UK No. 1 single, 'Y. M. C. A.'. On the 7th of January 1967, Chris Rea began his 'Road to Hell' tour at Wembley Stadium. On the 8th of January 1935, Elvis Presley was born. On the 9th of January 1968, the UK Post Office honoured by the UK Postal Service with the issue of a commemorative stamp featuring the king. On the 10th of January 1967, Dave Matthews was born. On the 11th of January 1971, John Lennon's 'Imagine' began a 4-week stay at No. 1 in the UK singles chart - the track had originally be recorded ten years earlier.

[... extensive daily music history entries continue throughout the page ...]

365 days of music

Brand identity and promotional launch material for production company Bouffant

certainly is a misguided idea that conservative decision-making maximises the bottomline. In my experience this cannot be further from the truth.

Q. How do you approach the day-to-day business aspect of running a design studio? Is this a skill you've had to learn through trial and error or is it a component you outsource? How do you generate new business?

I love running the studio with my business partner Rudo Botha. We have very complementary approaches to organising the business. At the end of the day we are interested in achieving a 'quality of life' and as a result we don't feel the need to separate ourselves from the business. We enjoy what we do – and we know that is a privilege. We don't package our passion, we wear it on our sleeves and we use it. As for generating new business, we look to build valuable relationships, everywhere, which translate into positive word of mouth.

Q. What do you look for in clients?

Someone with courage. Someone with a desire to be better.

Q. What is the first thing you think of when you hear the word 'client'?

Possibility.

'Duco loves everything' – brand identity and packaging design for Dulux Duco

Q. Graphic design is a sector primarily characterised by small practices, tight collectives or, more often, studios creatively driven by one person. Do you see this model of independence, relative autonomy and singular vision set to continue or will our design talent be gobbled up by larger commercial interests and allied industries both domestic and foreign?

This depends on the industry. The more profitable individuals and collectives are the greater the chance that some clever business people start organising bigger entities that incorporate these individuals into big companies and thus steer profits into their own pockets. Personally I don't have a preference for either of these scenarios. Each has its merits and demerits.

Q. Briefly describe your design education?

Information Design at the University of Pretoria and freelancing for three years in Europe and America.

Q. In your experience, do you think design schools adequately prepare a student for the demands of professional practice? What would you change about your design education?

The biggest lesson I learned at university was the naive pursuit of perfection. I would encourage all schools to embrace a culture that strives for perfection at every level – it creates passionate people and weeds out mediocrity.

Q. What influences your decision-making when interviewing and hiring creative staff? What are you looking for and what differentiates one young designer from another?

For me it's all about ethics, integrity, enthusiasm and raw talent. The rest can all be learned.

live on the Coke side of life

Coca-Cola

Graphic design as part of global branding campaign dubbed 'Coke ReMix'

Bouffant

Above:
Identity design for production company, Bouffant

Left:
'Betonoerwoud' – visual brand theme for a Lucky Strike event

Opposite bottom:
'The Art of Science' – brand engagement for Ipsos-Markinor in the form of fifty original pieces of art designed to create conversations around the company, its brand and its product

Q. Without viewing their portfolio, or knowing anything about them, what advice would give to a young South African designer beginning their career?

Follow your instinct and nurture it. It's amazing where it will take you.

Q. Despite the establishment of successful events like the annual Design Indaba conference, as well as institutions like Think (Design Council of S.A.) and coupled with the legacy of the Loerie Awards – the graphic design sector seems to moving both at quite an uneven pace, and in multiple disparate directions. Firstly, do you agree with this statement? And secondly, what reasons or factors (commercial or socioeconomic) do you attribute this to? Do you think government is lacking in this regard? Or is there something absent within the industry itself?

Yes, there is fragmentation. But that is not negative. It mirrors the world we live in.

Q. What is the best thing about being a graphic designer?

Every day you get better at it.

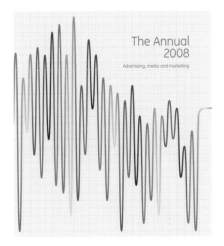

Editorial design for *The Annual 2008*, a publication by Jeremy Maggs and Future Publishing that provides a snapshot of the advertising and media industries

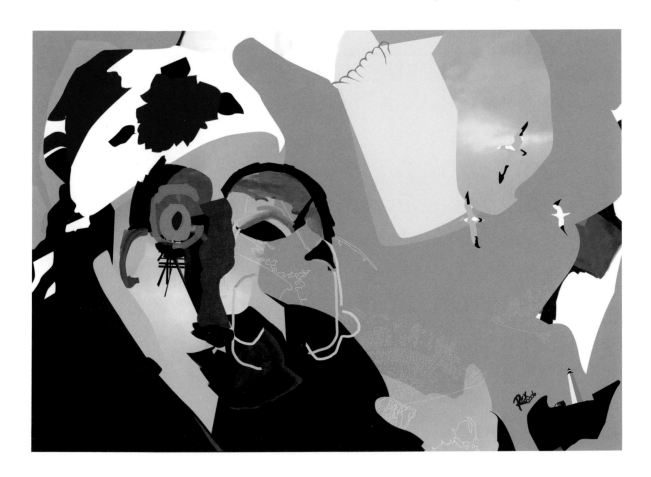

An interview with Carina Comrie
Creative Director – Bon-Bon, Johannesburg

Biography

Carina Comrie holds a BA FA in Information Design from the University of Pretoria and is the sole member and founder of Bon-Bon, a design studio in Johannesburg. She works extensively in the fields of heritage, visual arts, way-finding and exhibition design. Carina worked for several leading Johannesburg design companies before starting her own design studio called Fever with partner Lou Louw, focused on design for print. In 2003 Carina went solo and started Bon-Bon. Most recently she designed the exhibitions Gandhi: Prisoner of Conscience; Mapping Memory; the Freedom Park temporary exhibition and the Liliesleaf permanent exhibitions. She designed the books *TAXI-008 Steven Cohen* and *TAXI-009 Kagiso Pat Mautloa* (TAXI Art Book series, David Krut Publishing, 2003); *Number Four* (Penguin, 2005); *Mapping Memory* (Constitution Hill, 2006) *Briewe aan 'n Rooi Dak* (Handdruk, 2006); *Groceries* (Lapa, 2006) and *Great Lives: Pivotal Moments* (Jacana, 2008).

Q. Why did you become a graphic designer?

I suppose I was predisposed to it by a number of factors. My first hook was an early addiction to the smells of inks and paper and the magic of print, which had its origin in childhood visits to my uncle's old-fashioned print factory in Pietersburg. The next push came from growing up with a Dutch mother who had the principles of design engrained in the way she organised the world. She had a natural inclination for spotting a problem and in a symbiotic relationship with my father, who thrived on trying to solve them, laid down the foundations of my future. In this lies the essential function of design – finding the shared problems and trying to solve them. In the inherited pursuit of finding solutions and a will to find the meaning of life and existence through the process of making things, I found myself drawn to the charms of being a designer. Design is not a form of self-expression as art, which has its origin very much in [the] personal. Design has a societal function. It speaks to our common values as beings. In a broad sense it is a pursuit of universal balance and harmony through rational solutions. Design is appealing because the process creates inspiration that is engendered by the empathy among human beings in our common values and spirituality.

Q. What is your design education?

I completed a Bachelor's degree in Information Design at the University of Pretoria in 1996.

Q. What were the conditions under which you started Bon-Bon? What inspired you to start up on your own?

I left the corporate design industry three years prior to starting Bon-Bon. My career started out in broadcast graphics and animation. Two years later I exchanged those momentary compositions in time for the tranquillity and permanence of paper and print. I spent the next three years learning as much as I could about print design, its processes and possibilities, its nature, precision and magic. A time for exploration in the field of design of emotion had begun. According to life's intelligence I met the perfect business partner who could do everything I couldn't. We took the plunge in the pursuit of designing from the heart, inspiring and exploring the joy of humble design in everyday life. We spent three years carving out a niche in servicing visual arts and cultural institutions through design. The rewards were utterly fulfilling but financially challenging and the survival of the business necessitated taking corporate clients on board. The balance soon toppled and we found ourselves trapped in the bondage of commerce, leaving us with very little time and liberty for design from the heart. We made the strategic decision to split the business. I went on my own and created Bon-Bon, a studio that caters exclusively for visual arts

Opposite:
Poster design for Gandhi: In His Time and Ours

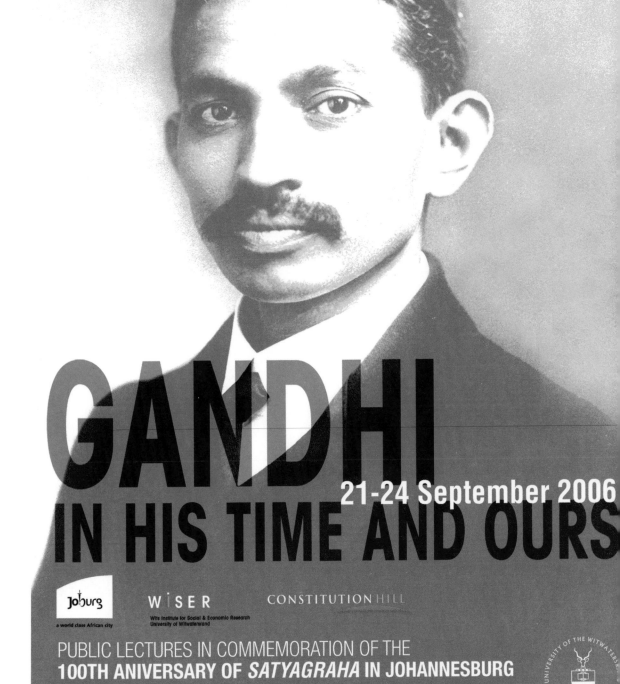

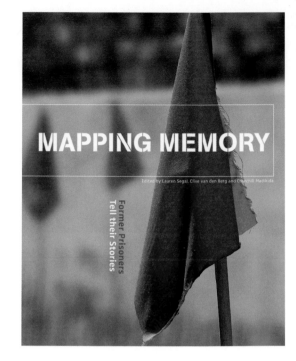

Clockwise from top left:

Groceries: 56 Stories Oor Huishoudelike Produkte by Harry Kalmer, published by Lapa Uitgewers; *Mapping Memory: Former Prisoners Tell Their Stories*, published by Constitution Hill (cover & spread)

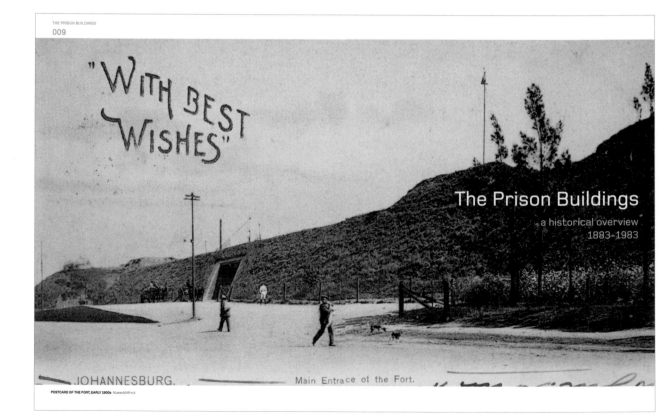

institutions, cultural and heritage foundations and publishing houses. I am close to the nature of myself and to the information I'm imparting.

Q. Do you think there is a distinctive stylistic trend or intent common to your work as a whole over the years? Does this relate to a common design philosophy? That said, do you feel design philosophies have any currency?

The intent of my work is honesty and integrity. Honesty to the message, the product the client and integrity of the medium and processes applied. It's always about imparting information and doing it as elegantly and appropriately as possible. I work instinctively and trust my gut, I have not gotten close to forming a design philosophy – the idea scares me, as it would take away from the natural flow and pleasure of creating with humility.

Q. What role does design theory play in your daily activities as a designer?

ALL PRACTICE. NO THEORY.

Q. What advice (creative, life and/or business) would you give to a young designer starting out?

Find the specific thing it is you love about design, specialise, zoom in expand it, grow it and love it as it will consume a large part of your life. Identify exactly what you want to give and what you hope to receive in return.

Q. Describe your primary design influences as a young designer or during your design education?

I have a solid connection with my Dutch forefathers and their simple Modernist approach to design. They operate from the basic belief in the knowability, visibility and perfectibility of the world, and from a no-nonsense documentation and reorganisation of that world. Dutch design has a strong emphasis on clear and clean visual organisation in an attempt to efficiently mirror and reorder the world around it. Design can give our world back to us in a way we did not know it before. It awakened in me the need to see, know and make. As designers we are not always required to invent but often simply to reorganise that which already exits.

Q. You work extensively with visual artists and cultural institutions; talk briefly about this niche specialisation and the challenges and rewards involved. Would you encourage young designers to specialise in servicing niche sectors or industries?

It is the greatest joy to know your passions and to integrate them into your work. I have a love for people and their stories, life and its expression. I have found my function in the memorialising of the past by creating a vocabulary for untold stories and often misinterpreted expressions through graphic design. Bringing them close and making them accessible and understood is my biggest reward. As I am working I am learning, as so many of these stories have hitherto been unknown to myself.

The challenge is that the weight of our past often becomes too heavy to bear but the reward is that while translating or relaying the message the future is illuminated.

I would encourage specialisation, as it gives you an opportunity to really understand the subject matter that you are doing and to get really good at it. But, as the saying goes, never put all your eggs in one basket.

Q. What role do style and fashion play in your work?

I do what is appropriate for the job in the simplest expression. The nature of my work does not always allow for fashionable or stylistic interpretation but design by nature applies a style to the message communicated. The style applied in my work is derived from the content, story or body of work represented and most often merely serves as a support to help the voice of the art, history or site to speak clearly.

Q. How do you approach the business component of running a design studio? Is this something you have had to learn by trial and error or is it a specialised skill that is outsourced? What key lessons have you learned from this aspect of the business?

I've learnt everything I know about business administration from and with my previous business partner. We made every mistake in the book and I still burn my fingers from time to time. I do my own business administration and find it extremely challenging at times. Weeks go by where there simply is no time for filing, invoicing, costing etc. So I end up having to handle this part of my business at night. Not too good for my social life but it is great to have my finger on the pulse and to know exactly what the financial health or ills of my business are.

Key lessons would be:
– Protect yourself with a set of standard terms and conditions.
– Get a client signature that agrees to your fees and terms and conditions before proceeding with a job.
– Set up legal contracts for jobs and always keep a paper trail of all negotiations and agreements.
– Trust your instinct, it's never wrong.

Q. How do you generate new business?

So far it has always just been there in abundance and I've never needed to go out and generate new business. I think I would be particularly bad at going out and finding new work so I better read the other guys' response to this question so I can be prepared when it hits.

Q. You are based in Johannesburg – what do you gain from this context that cannot be found elsewhere? What are the challenges of working within this context?

It is an environment rich with reflexivity. It often offers a mirror to reveal the nature of us, our country and our place in time. I find it incredibly enlivening to live and work here as the realities are on the surface and they are shared. We are affected by the past and we have a chance to be a part of writing our future.

Q. What are your views on the design industry in South Africa?

We have a great responsibility as designers in this country and my sense is that more and more designers are realising their primary social calling. There are meaningful opportunities here and we need to apply our voices to the messages that need to be heard.

Q. In your experiences, do you think design schools adequately prepare a student for the demands of professional practice? What did you enjoy most about your design education?

I can't comment on this as I have not worked with young designers or students in recent years but I don't think any school or institution can fully prepare you for professional practice. If you have the enthusiasm and passion and dedication demanded from design you'll be fine regardless of your education. I loved the awakening; it's a major transition in life when everything suddenly opens. Your mind, your heart your eyes and it seems like anything is possible and you are the master of your destiny. I loved the feeling of the world expanding around me and knowing that I have made a choice to take a journey of my own. History of Art was my biggest love.

Q. What role do you think apprenticeships or internships play in the professional development of a young designer?

They are valuable sneak previews into the realities of the job and give young designers an opportunity to feel out the way ahead. Internships give young designers a chance to contribute to a reality that

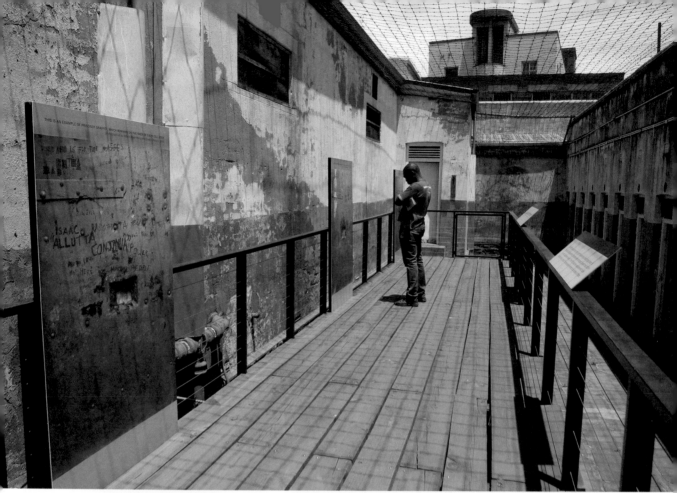

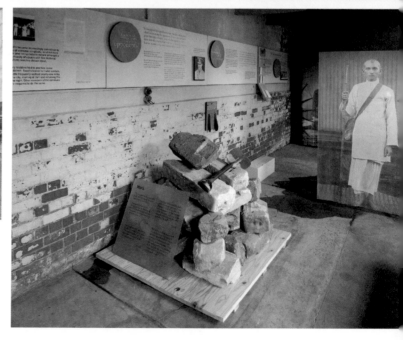

Top:
Design for Constitution Hill exhibition titled Number Four

Above & right:
Design for Constitution Hill exhibition titled Gandhi: Prisoner
of Conscience

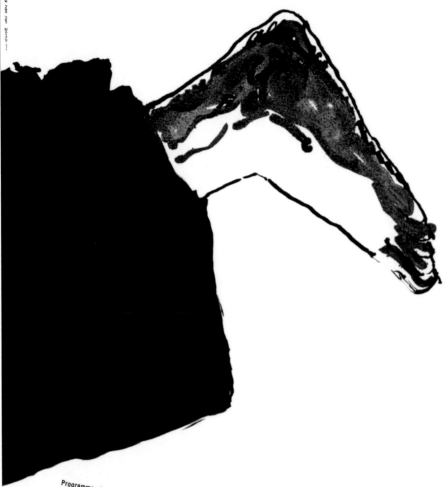

Programme of colloquia and public lectures, **WISER**, University of the Witwatersrand **17-22 May 2004**

THE PROMISE OF FREEDOM
GLOBAL PERSPECTIVES ON SOUTH AFRICA'S DECADE OF DEMOCRACY
AND ITS PRACTICE

EUROPEAN UNION

WiSER

Wits Institute for Social & Economic Research
University of Witwatersrand

For programme phone 011 717 4234 or visit www.wits.ac.za/wiser

often feels very distant while you are studying. It creates the sense that they are already part of a bigger family and gives them goals to aspire to. It builds confidence, clarity and vision and creates context for their studies.

Q. What are the most difficult things about being a graphic designer?

Sitting in front of a machine for a ridiculous amount of hours.

Q. What are the best things about being a graphic designer?

You learn about things in the world you never would have otherwise. With every new job you are immersed into a new world of information. While you are translating the message you get to know the meaning, the people and the truth.

It affords you great freedom and time to do all the other things you love. If you plan your year well enough you can afford yourself long holidays to beautiful faraway places to fill yourself with inspiration and joy which are essential components for keeping goodness flowing.

And off course you get to buy a new Mac every few years!

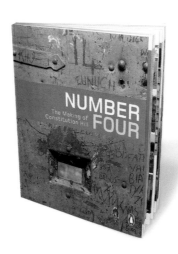

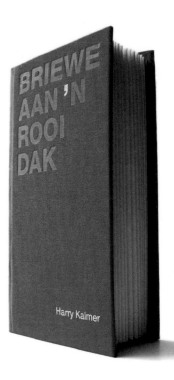

Above from left:
Editorial design – *Refiguring the Archive*, published by Kluwer Academic Publishers, New York; *Number Four: The Making of Constitution Hill*, published by Penguin Books; *Briewe aan 'n rooi dak*, published by HANDDRUK

Opposite:
Promotional poster design for WISER lecture series (Wits Institute for Social and Economic Research)

An interview with Richard Hart
Creative Director – disturbance, Durban

www.disturbance.co.za

Biography

Born in Scotland 1968 at age nought. Kidnapped a neighbour's baby at age three. Started The Nature Club at age six (David Attenborough was a fully signed up member!). Moved to Rhodesia at age eight. Learned how to make deadly catties (catapults) at age ten. Moved to South Africa at age twelve. Started surfing at age thirteen. Got a steady girlfriend at age sixteen. Got laid at age seventeen. Studied graphic design at Natal Technikon under Brian Andrew and his all-star staff. Worked for a short while at SA Clothing industries... Wrangler jeans. A year in the SA Vloot. Designed *Navy News* for a few issues, screenprinted T-shirts, got drunk, defaced government property and had fun wasting a significant amount of tax payers' money. Left the navy and the country, travelled for four years doing odd jobs and the occasional bit of design. Returned home. Worked for six months on *Soul Surfer* magazine. Learned how to start up my new Mac and before long, how to do cool stuff with it. Started disturbance with partner and sister, Susie.

Q. Why did you become a graphic designer?

To do *Yes* album covers.

Q. What is your design education?

National diploma in graphic design.

Q. What were the conditions under which you started disturbance? What inspired you to start up on your own?

Conditions were overcast with occasional drizzle. I had no agency experience and didn't really want any. Working for myself seemed wild and radical and independent when it probably should've seemed daunting and scary and a bit stupid.

Q. Designers generally specialise – whilst your core focus is illustration, your work covers a wide range of cross-media. Would you encourage young designers to specialise or diversify their skills?

I think it is both intentional and a reality of working in South Africa. From the get go I was pretty comfortable doing a wide range of things and the thought of specialising and focussing on one small area seemed a bit daft when there was the possibility of always doing something new. I think dabbling in everything is a good recipe for a happy career. However, few people get rich and famous dabbling. So if you want to be Andy Warhol pick up a squeegie and never let it go. If it's fun you're after, do everything!

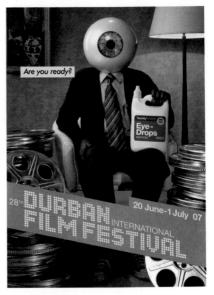

Promotional poster for Durban International Film Festival 2007

Promotional poster for Durban International Film Festival 2006

Opposite:
Self-initiated poster design

Our bodies split the night in half.

With apologies to Kevin Drew

Q. Do you think disturbance reflects a distinctive stylistic trend or intent common to your work over the years? Does this relate to a design philosophy? Do you feel design philosophies have any currency?

I don't know if our work is stylistically consistent, but there is definitely a common thread running through much of what we do. I have always felt that honesty and sincerity are vital ingredients for good work and I guess that has meant doing work that is true to who I am. Often I've wished our work to be more sophisticated or less corny or more avant-garde or... whatever. The truth is the work comes out the way it does because I don't know another way and would prefer not to simply dress it up in a certain style to fit in with what's around at the time. That said, I don't think we are entirely immune to the influences of the world around us and I often look at older work we've done and groan in embarrassment.

Q. What role does design theory play in your daily activities as designers?

Less than zip.

Q. What advice (creative, life or business) would you give to a young designer starting out?

Creative – read books. The best design by the best designers has all been published. Study it in minute detail and figure out what makes it work. Then go and do something different.

Life – spend as much time as possible out of your comfort zone.

Business – find someone clever and trustworthy and leave the business stuff to them. (Take special note of the trustworthy bit!)

Q. Describe your primary design influences as young designers or during your design educations?

I was more influenced by musicians and illustrators/artists than designers. Sonic Youth, Pavement, The Flaming Lips... I loved music that was a bit shambolic and messy, which I think informed my visual style a bit. Reg Mombasa, Anita Kunz, Marshall Arisman, Barry McGee and Rita Ackermann were my visual influences.

Q. disturbance is well known for your strong illustration work; who is largely responsible for this and what developed the interest in illustration?

I have traditionally been the illustrator at disturbance, though fortunately we have recently hired some very strong designer/illustrators. I had always been interested in illustration and when we first started out it seemed to be a way of keeping everything in-house. Illustration was also less common when we began, so it was a good way to differentiate our work from everyone else's.

Q. That said, your work is also – relatively recently – characterised by an increasingly strong photographic component. Is this a conscious decision or simply a phase?

To some extent our moving away from illustration is a conscious backlash against the current ubiquity of illustration. It somehow seems less fun to

Identity and editorial design for Sunday Tribune, *SM Magazine*

The cover of issue 15 from the self-initiated publication series titled *Sheet*

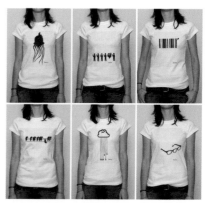

disturbance self-promotion t-shirts

Opposite:
Self-initiated poster design

be doing it when everyone else is doing it. Another reason for our move to photography is Roger's [Roger Jardine is a partner at disturbance] recent appointment as a partner in the company and his increasing prowess as a photographer. We have invested in cameras and lighting and have even set up a small studio, which has opened up possibilities to do something new.

Q. What role does humour and/or irony play in the work of disturbance?

I'd say humour is pretty much the cornerstone of any underlying design philosophy we might have. It's not always in your face, but we definitely get a huge kick out of making people smile... or, if we're lucky, laugh!

Q. How do you approach the business component of a running a design studio? Is this something you have had to learn by trial and error or is it a specialised skill that is outsourced? What key lessons have you learned from this side of running a design studio?

Personally I have very little to do with the business side of the company. It's a source of both pride and embarrassment that I have never once looked at our books in eleven years of business! Having said that there are obviously areas where my input is crucial to the success of the business. This has been very much a case of trial and error. I guess the norm of starting up a company in the creative industry is to cut your teeth for a few years at one of the big agencies. Then team up with one of the senior client service people and hopefully steal a client or two to get you going. In our case neither Susie nor I had any agency experience whatsoever. Nor any contacts or clients. We literally started as cold as is possible... and as naive! So over the years we've pretty much figured out how it should work by trial and error. Highly inefficient I'm sure, but somehow it has all worked out.

Q. How do you generate new business?

I have no idea.

Q. The disturbance brand has ventured into numerous allied creative and service industries: product development, industrial design and even designing and running a restaurant and bar (Home in Durban). Briefly describe the successes and challenges associated with these ventures as well as the motivation behind diversifying to this extent. Would you encourage other design studios and designers to follow this model?

To be honest none of our extra-curricular activities have really paid off. But we are incredibly passionate about what we do. We are ideas people and sometimes those ideas don't fall neatly into the category of graphic design. That's usually when we lose a truckload of money! Of course we never set out to lose a truckload of money. The intention is always to broaden the scope of what we do as designers. In spite of some fairly spectacular fiscal failures, I think mucking about where we shouldn't have has grown us as creative thinkers. It's also been a whole lot of fun... which is pretty much all that counts in the end.

Book cover design for *The Ben Trovato (mis)guide to golf*

Illustration for *Design Indaba* magazine for an article on consumerism by Kalle Lasn

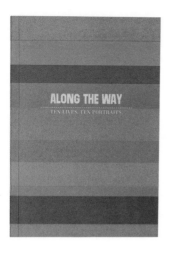

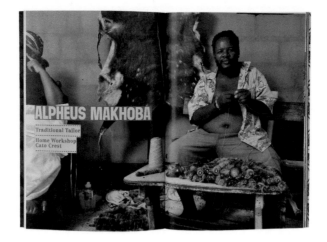

Editorial design for a 48-page book, *Along the Way* (cover & spread)

Packaging design and photography for SUPERHOTJOY CD

Packaging design and photography for Aiden Cornhill CD

Q. A number of design practices in South Africa have gained profiles, acclaim and opportunity through self-initiated design projects and publications. Here I am thinking of yourselves with *Sheet* and *These are a few of our favourite things*; Garth Walker of Orange Juice Design with *i-jusi*; Peet Pienaar and Heidi Chisholm of daddy buy me a pony with *Afro Magazine*. Is this a model you would encourage in students and why do you think print magazines are the dominant medium for its delivery?

As graphic designers the best way for us to promote ourselves is through doing graphic design (duh). Publications are graphic design from cover to cover (and often in the case of design publications contain very little other than design). Depending on how far you wish to take it, publishing can be a fairly cost-effective means of getting your work out there... although it must be said, not as cost-effective as using the web. I think it is a fair model for students to follow but with a caution: think before you print... if a bunch of trees are going to be cut down for your little ego trip, be sure you're putting something of value out there.

Q. What are your views on the design industry in South Africa?

Pound for pound I think we are on par with any country in the world. We just need to have the confidence in it without constantly looking for affirmation from the rest of the world. I think this extends beyond design.

Q. In your experiences, do you think design schools adequately prepare a student for the demands of professional practice? What did you enjoy most about your design educations?

Not really. I am usually appalled at how un-ready students are for the workplace after three years of design school. Yet on the flip side there are a lot of very accomplished younger designers out there. My main criticism of design schools is their obsession with teaching software packages as opposed to conceptual thinking. A software package can be learned at home in the evenings or in a few short months on the job. Ideas are the real currency of design, not Photoshop skills! Teach ideas!

Q. What are the most difficult things about being a graphic designer?

Photo shoots with supermodels. What a drag.

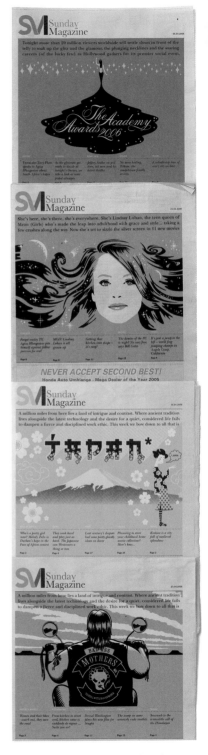

Assorted cover designs for the Sunday Tribune, *SM Magazine*

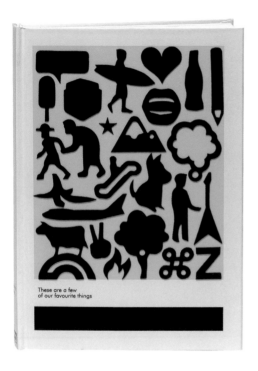

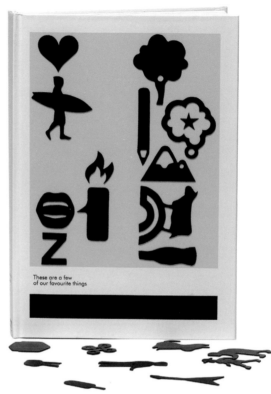

240-page monograph on the work of disturbance, *These are a few of our favourite things*, with hard-cover, magnetic graphics

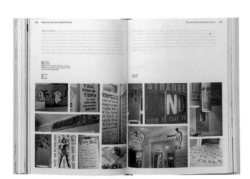

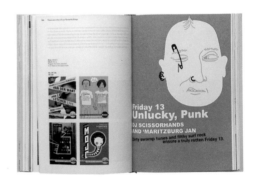

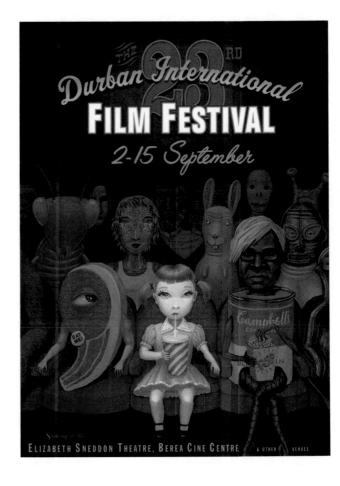

Above:
Packaging design for music CD compilations

Right:
Promotional poster for Durban International Film Festival 2003

Opposite:
I.D. Magazine cover

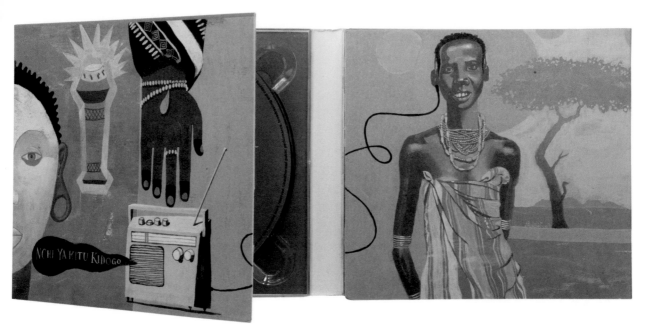

THE INTERNATIONAL DESIGN MAGAZINE — *Italy's Neglected Generation* ... Almost-Impossible-to-Make Products
A Day in the Head of a California Designer ... Tivoli Gardens' Makeover ... 6th Annual Student Design Review
September/October 2006 — www.id-mag.com

I.D.

Signs of
Disturbance

Designing on the edge
in South Africa

An interview with Garth Walker
Creative Director – Orange Juice Design, Durban

www.oj.co.za

Biography

Garth Walker started Orange Juice Design in Durban in 1995, designing for many of South Africa's best-known brands. Beginning in the late eighties, Garth began to document the 'world around him' with an emphasis on 'street design', and the then emerging graphic styles of Durban's pavement traders. The collection now numbers some 5000 images of everything from hair salon fabric banners to granite 'biker' gravestones from every corner of South Africa. This focus on the vernacular unique to Durban, South Africa and across the African continent manifests itself most obviously in his self-published magazine *i-Jusi*, which raises questions about the effects of culture on design. A firm believer in the importance of the local, Walker is principally concerned with understanding what makes him an African, and how to be honest to the culture that reflects his true self.

Q. Why did you become a graphic designer? Not how, but why?

I became a graphic designer by accident. I was useless at school. I wasn't interested in maths or science. So from standard six to standard nine it was a slippery slope. By the time I got to the end of standard nine I was so mathematically and scientifically behind that there was no chance of a Matric. I never studied art. And then my father retired and we moved to Durban and I was gonna go to Damelin on a rescue mission. I could grow my hair, smoke a cigarette and they guaranteed they would get you your Matric. I went for this interview at Damelin and the guy said to me "look if you've got an interest in art, there's a one-year experiment being run here at a school in Durban which means you get an Art Matric." So like a flash I was over there. So, from Matric my destiny was pre-determined, in that I had automatic entry to the graphic design degree at Technikon Natal. So I went to the army first and then went to Tech and discovered that graphic design and I were happy campers.

Q. Designers often specialise within one discipline or medium. Whilst your core focus is design for print, your work covers a wide range of media and disciplines. Would you encourage young designers to follow this model?

Graphic design in primarily print and photography are the two things I like doing and because in professional design I have to get involved in animation and digital and audio – radio commercials and stuff for clients – I dabble in those things. But it's primarily print-related graphic design and photography. I'm not big on illustration. So I would say concentrate on your core skills. If you're a natural draughtsman don't lose that drafting ability... do as much illustration as you can in your personal capacity. If you're a graphic designer and you haven't developed an interest in photography but feel that you quite like photography I would encourage you to get involved. I think you have to become master of something, you can't be a jack-of-all-trades, I've never met a designer yet who has been a jack-of-all-trades. Most of us can work in a number of media but you'll find, certainly in Europe... if you're a poster designer and that's your style of poster and that's it, they don't kind of do other stuff. But locally it means that you've got to have more arrows in your quiver but you need to master the ones that you are good at and the ones that you like, and concentrate on those.

Q. Do you have a philosophy that influences your design on a day-to-day basis as well as the way you view design as a life-long endeavor? That said, do you feel idiosyncratic design philosophies have any currency?

Opposite:
Self-initiated poster design

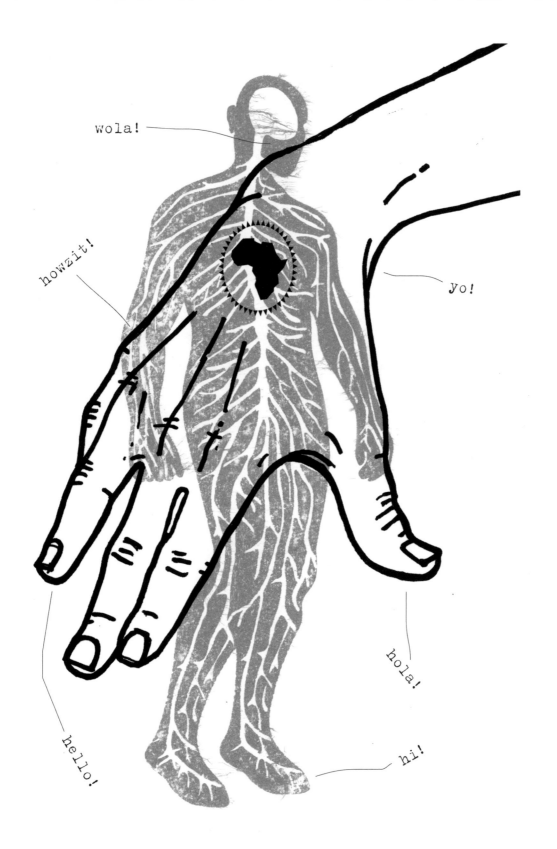

wola!

howzit!

yo!

hola!

hi!

hello!

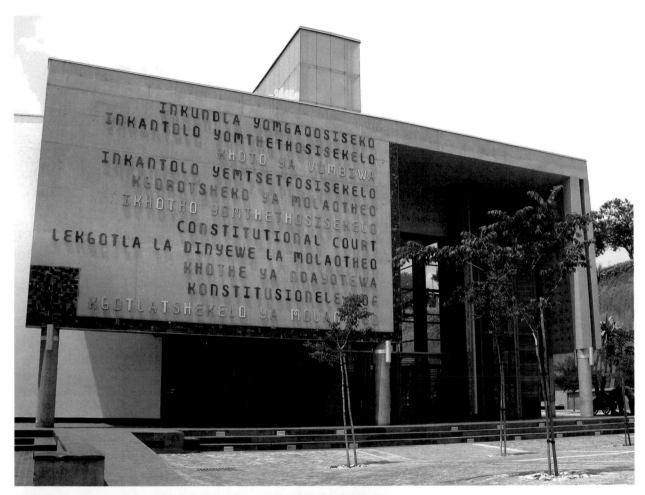

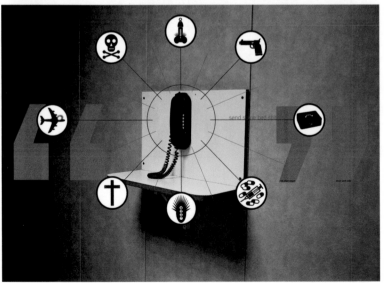

Above:
Typographic design for a custom-made font for the
South African Constitutional Court, Johannesburg

Left:
80/80 collaborative artwork designed by Garth Walker,
featuring a photograph by Olivier Mirguet

I have a philosophy that's a bit anti-design. It is that we are actually not in the design business, we are in the opinion business. My industry is an opinion industry and therein lies the problem for all designers because everyone walking the earth has an opinion. And because we are not a science but an art, and because art is a matter of opinion it [means] we're vulnerable to clients saying that their opinion is as valid as yours. So, you need to understand that otherwise you're gonna fall on your sword and bleed all over the floor and no-one is going to care. Consequently, the philosophy of design is, forget about design. You have to develop an opinion and learn how to offer that opinion so that it becomes the modus operandi. You have to be a psychologist, you have to know stuff, you have to lose the battle to win the war. ...a lot of designers don't understand that it's an opinion-based profession and they come in with this high and mighty attitude that their opinion is the only opinion. I'm wary of designers that come with a sort of philosophical thing – architects tend to do that, they expound all sorts of stuff, like architects.

So you have to substantiate and support and validate the perception that you're an expert, which means that the first thing you have to do is that you have to become a good communicator. Graphic designers I have found are always good communicators. Graphic designers I've found are also very good writers. They are just not confident in their writing ability but every kid I've ever had in the studio can write like a dream – better than our copy writers – but their perception of writing is traumatic, filled with fear, they are insecure, much like we are about our bodies, you kind of dress good but take your kit off and... An analogy that I use is that when you go the dentist you sit in the chair and they put this mask on. ...there's all this strange gadgetry around you and he's got a mask on and rubber gloves and everything kind of adds to the fear and he says 'now I'm going to make this pain go away'. Then he starts doing all kinds of things that are completely alien to your experience, yet your perception of this guy is that he is the expert, he's the dentist, he knows what he's doing, he's going to solve the problem. We need to be the dentist doing the fillings and if you can get the client to put their faith in you, you have automatically got the upper hand when it comes to making an opinion.

Q. And the client has to make that leap?

Yes the client has to make that leap. So if you get a client who's not buying into your expertise then don't take them on as a client because the client is not going to play the client role. We want clients that want us to provide the thinking they don't have. So the relationship is structured around the need and us being able to fulfil that need. On the understanding that it's an opinion; so you have to accept that there might be another opinion other than yours and be big enough to say that actually that probably is a better opinion than mine, so let's take that opinion and adapt it, using design principles and end up with a better piece of design. And that, more often than not, is what happens. That's the thing that a lot of designers – because we're in an ego business – can't get around. They want that typeface and it must be green because that's the only way and if they open themselves to other opinions and they're not dogmatic in their philosophy, they will say well 'you know, to be perfectly honest I did change the typeface and I changed the colour and I actually think that it does look better'.

Q. Where do you think that inflexibility comes from?

We are in an ego business and we're born with a talent that's not given to everyone. A lot of people think that makes them special, and it's a very competitive industry. I've met many of the best designers in the world – a dreadful expression – and the great ones are the most wonderful people because they understand how hard this is, and they themselves still have that insecurity and it's that insecurity that they can do better work, that they haven't done their best work and there's more in them and there's more to come, that keeps them going. I mean Alan Fletcher was the most... I mean he was a pain in the ass in many respects but to me and to many other designers, he was a wonderful guy. And he didn't think he was the bee's knees. But a lot of designers do. Stefan Sagmeister who I know well doesn't sort of walk around thinking that everyone else is an idiot. And because it is an opinion thing... the really good designers are idiosyncratic and are kind of odd, but it's part of the charm and it's part of what makes them good designers. You have to be a maverick as a designer, you've got to swim upstream. You cannot do this job by fitting in. You have to fit out. And a lot of people, on the not fitting in, get it wrong.

Q. Without viewing their portfolio, or knowing anything about them, what advice would give to a young South African designer starting out?

My view for hiring and assessing is fifty percent talent, fifty percent nice guy. I've had one hundred percent talent but he was toxic as a human being and there's a trail of dead bodies in his professional relationships because he's talent and there's nothing else. I've had other people here that are the most wonderful people that you would pray your daughter marries but they don't have any talent, they've got limits. So you've got to get that combination right. That's fairly easy to spot because the nice person is all the stuff around the portfolio, it's kind of how they come across. You know: are they on time, how they dress, how they speak to you, how they relate to you. All that sort of stuff, before you even see the portfolio. It's the classic blind date. There's no difference between meeting a woman in a bar and a new guy that has come into your studio, it's exactly the same people dynamics, the graphic design part is irrelevant.

Q. A number of design practices in South Africa have gained profiles, acclaim and opportunity through self-initiated design projects and publications. Here I'm thinking primarily of yourself with i-Jusi; Peet Pienaar with *Afro Magazine*; and, in a different sense, disturbance with *These are a few of our favourite things*. Is this a model you would encourage in students and why do think print is the dominant medium for its delivery?

This whole African thing happened for me by accident and I'll give you the background because it may help you to understand where I came from and why... My father always said that life is something that happens while you are making plans to do something else and graphic design and the route I took were exactly the same: it happened by accident, there was no grand master plan. I stayed a graphic designer instead of going into agencies and art direction, which a lot of people did in my day simply because there were more ad agencies so there were more jobs going. It was '76, there were riots, there were no jobs. So I ended up being a graphic designer... and one of the forks in the road was when I went on my own. I had no work and I spent six months literally... waiting for all these clients to beat down my door because I wanted to do great work. So at the six-month juncture I thought I've got to actually have a project that I can keep myself occupied with. Every designer I've ever met wants to do a magazine and I thought I'm going to design a magazine, I don't know what I'm going to do with the thing. It was '94 so everything was kind of new. Historically I had always collected African stuff. So I had a collection at home of beadwork and Zulu headdresses and things. In the late eighties I had started documenting a street vernacular, because I liked it and for no other reason... so I was going do a design magazine along the lines of... I didn't think how I was gonna print it or if I was gonna print but then I thought to myself, no hang on, there's no point in designing a magazine like every one else is. And I mean in those days – this is in '94 – you couldn't go to CNA and buy a design magazine. There wasn't one. And I thought, no hang on... let's experiment and try and design an African magazine, whatever that was.

It was '95 by the time the first one came out. The first Durban issue. So I started scouring around for all the international design magazines and mailed the thing off... and obviously what happened was that some guy was sitting at a design magazine in Germany or America and on their desk lands this thing from South Africa, [a country] that's been locked up for thirty years. [But] they've just had the glorious revolution of Nelson Mandela and the Rainbow Nation and dancing in the streets and everyone was on a high about South Africa, and oh my God here comes a graphic design magazine from South Africa, get hold of this guy and tell him we want more. So I got massive exposure in all of those design magazines and it became very apparent to me by the time issue one had sort of like got out there that I was onto something and it didn't cost me anything. I had these guys that were printing it, I had got the paper and I had all this fun of doing this thing. So I did the second one.

Q. How do you approach the day-to-day business aspect of running a design studio? And, strategically, over the short- to mid-term, how do you generate new business?

I hate management, I'm big on denial and head in the sand because I'm not interested in it, but I've sort of done enough of it to keep us going and pay salaries and keep the doors open and save a bit of money for twelve years and business is not rocket science. To grow it and make it bigger is more focused but I'm not really interested in focusing in that regard. You learn that you do need a certain amount of system and you have to stick with a system and often that system can be confrontational and painful, and you have to

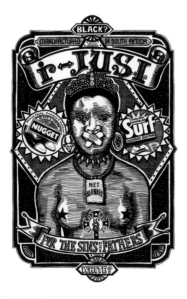

This page:
Design elements from various issues of *i-Jusi* magazine, designed and published by Orange Juice Design

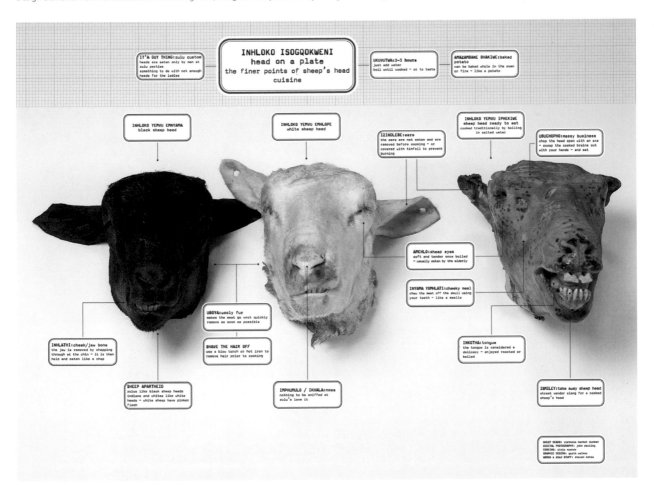

have disciplinary hearings and you have to be aggressive, simply because it's a fundamental requirement of business. It's got nothing to do with graphic design or being creative or are you a nice guy... but it's something that you have to do otherwise you don't survive... so my approach to business is to do the barest minimum I can to keep that component of it active so that the mechanics of business can function behind the scenes and then the rest of the time you've got to devote to being Garth the graphic designer. I'm unique probably in the entire industry at the level at which we operate and the credibility we have in that I still spend ninety-five percent of my day behind the computer doing the work.

Q. Graphic design is a sector primarily characterised by small practices, tight collectives or more often studios driven by one person. Do you see this model of independence, relative autonomy and singular creative vision continuing or will our design talent be gobbled up by larger commercial interests and allied industries both domestic and foreign?

The industry certainly in South Africa and globally is now becoming more and more a component of the business mix as opposed to a partner in the business mix, because more and more businesses are offering some or other loosely creative service, and corporates that aren't really interested, don't know, are looking to cut overheads, are one-stop shopping etc etc... so the small independent studio is going to be increasingly under attack exactly the same way that the corner butcher or the green grocer is because the filling stations are putting in cafes. So we are a dying breed and I don't see that changing. In South Africa it's even worse because it's exacerbated by the fact that all the agencies here are looking to other creative industries to earn revenue and one of them is design and a lot of the advertising spend is increasingly going into non-advertising. So you set up a design studio and you compete with all the ad agencies that are not design studios but they've got design as one of the offerings, as well as with other design studios. In Johannesburg the model is the big studios are big business. So in my view... at the end of the day they become successful businesses, the ingredients of their businesses are the sales of creative services but their work doesn't stack up.

Q. You live and work in Durban – firstly, what do you gain from this context that cannot be found elsewhere? Secondly, what are the challenges of working within this context?

I don't need to go anywhere else, I mean every photograph that I need to take is here. Yes it's nice to go on trips and I would miss it if I didn't but... seeing is intimately bound to your culture and your surroundings. I discovered that by this thing I was reading on Lee Friedlander the photographer which said that he struggles to see outside of New York. If he leaves New York he sees differently, he can't see. I've discovered that if you take me out of Africa I don't see the world in the same way so it's much harder to find what you're looking for. You have to really adapt... I've discovered that I can see in Durban and I don't see as well outside of Durban though I see perfectly alright in Cape Town, Bloemfontein, Vryheid, Johannesburg. I have a South African or even an African [sensibility] because I've been to other parts of Africa... in Africa I can see... So if I went to London and I adopted the same thing it would be a much more difficult journey to get to this point... and this is supported by guys that I work with over there that come from here and they come back here and they kind of haven't even driven out of the airport and they've taken ten... So Durban allows me to see.

Q. In your experiences, do you think design schools adequately prepare a student for the demands of professional practice? What would you change about your design education and/or those of the students you encounter?

I think our educational system does have flaws. I don't think art or creativity are taken as seriously as they should be. I think that South Africans... are incredibly creative... we are also more primary, much more violent so we have coursing through our veins more of the ingredients you need for creativity than you have elsewhere where it becomes much more intellectual and poncy and you either get it or you don't.

The government doesn't see this because they are obsessed with maths and sciences and becoming a nation of geniuses which is never in a million years gonna happen. I think economically our future lies much more on finding creative... opportunities for commercial gain than trying to churn out a whole lot of computer programmers from schools. But you know it's not sexy to see art as a saviour whereas maths and science are... our art schools don't have a system like everywhere else where people from industry are

Promotional poster design for AGI Conference (Alliance Graphique Internationale), Berlin 2005

paid to come in and teach students. We have teachers teaching students and industry employs them and never shall the two meet and by simple nature of mechanics, the guys that can't make it in industry go and teach because it's safe... if there were more money in design education to pay professionals to go in there to run workshops or even to approach them to do it for nothing... but there is not enough of a close link. If I go anywhere they ask where I teach and I say 'hey I don't teach' and they look flabbergasted: 'what do you mean you don't teach?' Every graphic designer who walks the earth teaches and gets paid for doing it, perhaps not as well as they do in their commercial work but it makes it viable and part of being recognised as a graphic designer is when you get asked to teach at the Royal Academy or the School of Visual Arts... That doesn't happen here. And it's getting worse.

Q. The idea that design inspiration is largely conditional upon various local temporal and contextual specifics like history, socio-economic structures, access to technology, the vernacular, language and culture is largely a given, and has proven currency. However, aside from being able to communicate a political message, how effective do you think design is at manifesting social influence, exerting a political will or affecting change?

This is a world-wide debate: that design for social change globally has been hi-jacked for business profit... have it designed so you can sell more of it for more money so that you can make more money. Designers have been happy to play along because they become famous for designing this chair or that chair or that logo and everyone makes money. I think cynicism worldwide post the 1960s, when everyone was concerned about their political and social viewpoint and [forget] the money and personal hygiene... and station wagon kind of stuff. That got beaten out of us in the 1970s, and the yuppie 1980s and [because of] the rise of globalisation where everyone sees everyone else as having more than what they've got and it's human nature to want more... To get that, you have to sacrifice your principles and get on the treadmill.

South Africa, because of its apartheid history and the size of the industry (which was miniscule), does not have much of a history – which comes as a surprise to many foreigners – of political design... Political graphic designers were not designing anti-apartheid posters and free Nelson Mandela t-shirts in their free time. That was being done by apartheid activists, which is why that visual language is so crude. But therein lies its charm. So throughout South's Africa's political and design history, graphic design has not been a force for social change and now with a government that's very confused on AIDS, we haven't been co-opted into a partnership to use our skills to the benefit of the public good on issues like poverty, education and AIDS... and we've now got a generation of young designers who don't come from any form of political descent or instability because they are post-1994... Their world is cell phones, designer jeans and international travel. And the Struggle and everything that went before is something that their parents or grandparents went through... I can't see that changing.

But this is a global thing: at all the design conferences I go to, this is a global debate... Why isn't design being more visible and why aren't designers playing a bigger role. And no one's answered it. I think the reality is human nature, that money is much easier to chase and more rewarding... arguably. So... if I look at my colleagues in Johannesburg... there is so much business there that to make sure you and not the next guy gets the business, you haven't got time to do any kind of pro-bono stuff... white South Africans – I can't speak for black south Africans – have got this thing that you might at a dinner party discuss politics, religion or money but you certainly don't go public with it because that's a no-no. I find Afrikaans kids are more politicised than English kids, which is probably historical. I mean *Bitterkomix* would never have come out of an English-speaking tradition. Afrikaners, when they go bad on their culture, tend to be much more radical than English kids. They're extreme. I've exhibited in Switzerland with Anton [Kannemeyer] and Conrad [Botes] and the Swiss were freaking out – they couldn't handle the stuff.

Opposite top:
FIFA t-shirt designs

Opposite bottom:
Illustration from *i-Jusi* magazine by Garth Walker